Re:Imaging Wales

A YEARBOOK OF THE VISUAL ARTS

Articulated Daffodils / Twilight at Worm's Head / Ein Gwaith Beunyddiol

Moonlight, Boathouse, Laugharne / Memories of Mwnt / Japanese Brid

Monet's Garden, Giverney / Spanish Gypsies / The Splendour Falls on Cas

Walls / Moonstruck Presli / Salubrious Passage / Canal Boat Wreak / A R

of Colour / Shower near Trimsaran / Gondola in Venice / The Road to Cast

Carreg Cennen Farm / Lakeside Cottage / The Ring Mistress / Green Shed B

Boat / Lost Heritage / Flower in a Vase with Dish / Llanelli's Garden

Remembrance / The Glory of Clyne Woods / Monks Rock / Across the Fields

Dunraven Estate / Buddleia and Butterflies / Mr. Badger / Celtic Cross

Worm's Head from Cefn Sidan / Lyn cooking Breakfast / Pithead Vigil

Remembering Burry Port Lighthouse / Aliens on Holiday Earth / Nude No. 9

Standing Stones in a Welsh landscape / The Destruction of the Creative Spirit

Dylan / Wild Flowers in a Little Jug / Miner's Head / Pretty in Pink /

Re:Imaging Wales

A YEARBOOK OF THE VISUAL ARTS

Edited by Hugh Adams

seren

Seren is the book imprint of
Poetry Wales Press Ltd
57 Nolton Street, Bridgend, CF31 3AE, Wales
www.seren-books.com

ISBN 1-85411-406-9
A CIP record for this title is available from
the British Library

Published with the assistance of the Arts Council of Wales
The publisher works with the financial assistance of the
Welsh Books Council

Printed in Meta by HSW Print, Tonypandy

Cover image: Cecile Johnson Soliz
'Property of a Lady' (detail) (2002-03)
clay, wood, paint 307 x 500 x 27cm (194 pieces)

Page 2 and 120 'Articulated Daffodils', a prose poem written
by Peter Finnemore in response and homage to works in the
collection at Llanelli Public Library

The editor and publisher welcome information, illustrations and
ideas for inclusion in our next publication in this series. Hard
copy, text, press releases etc. should be sent to Hugh Adams at
16 Marlborough Hill Place, BS2 8LR
catalysts@wideblueyonder.co.uk.
Captioned illustrations sent high resolution on cd rom or trans-
parencies are preferred to email attachments.

Contents

Hugh Adams	Is Incest Us?	6
Artists' Profiles	Keith Arnatt, Phil Babot, Paul Beauchamp, Pat Briggs, Susan Butler, Stefhan Caddick, Michael Cousin, Eve Dent	15
Debbie Savage	The Rôle of Artists' Networks in Wales	24
Artists' Profiles	John Paul Evans, Laura Ford, Arthur Giardelli, Paul Granjon, Andy Hazell, Rozanne Hawksley, Richard Higlett, Clive Hicks-Jenkins,	31
Iwan Bala	Take Me Somewhere Good	40
News, Views, Reviews		51
Artists' Profiles	Harry Holland, Paul Hurley, Bert Isaac, Cecile Johnson Soliz, Helen Ann Jones, Yvonne Jones, Christine Kinsey, Elfyn Lewis	81
Derrick Price	Imaging Wales in the Digital Age	90
Artists' Profiles	Sally Moore, Mike Organ, Richard Page, Paul+a, Richard Powell, Jennie Savage, Bedwyr Williams, Karla Williams	98
Debbie Savage	Somewhere Else: Wales in Venice	106
Notes on Contributors		114
Index		117

Hugh Adams

The editor in Venice

'The Welsh' said the Doctor 'are the only nation in the world that has produced no graphic or plastic art, no architecture, no drama. They just sing.'

<div align="right">Decline and Fall, (Evelyn Waugh, 1925)</div>

The trouble is that other nations have a visible culture, and so can enjoy their painting, sculpture and architecture with little difficulty, whilst the Welsh have, uniquely no visual arts at all, being confined to singing, brass-bands and poetry.

<div align="right">Follies and Grottoes, (Barbara Jones, 1974)</div>

Is incest us?

Combatting such bigoted and ill-informed claptrap as the two quotes opposite was one of the aims of my book *Imaging Wales: Contemporary Art in Context*, published in 2003. Even then one still heard it said, even in Cardiff, that Wales produced insufficient art to sustain a regular specialised publication and, in London, that Welsh art did not justify a separate representation at the Venice Biennale. The latter ignored the fact that Ceri Richards had already represented Britain in a one person show there, but then we are used to that embarrassing thing: the successful Welsh person suddenly being presented as 'British'!

Twice now we have amply demonstrated the capacity to do more than hold our own at Venice. It is obvious we can do so again and again...

Imaging Wales was jointly commissioned by Wales Arts International and Seren to coincide with Wales' first discrete presence at Venice and in order to demonstrate internationally the sheer quality, diversity and extent of that art not being shown, and to establish a context for what was. The book achieved widespread domestic currency and a very positive response, so a follow-up now seems timely.

I felt that another historico-critical overview, at least in my voice, seemed premature, hence the 'guest editorials' by Iwan Bala and Derrick Price, thus adopting somewhat the conventions of such professional yearbooks as Crockford's and Wiseden's. This publication is partly modelled on these, as a deliberate vehicle for polemic and information of record. Although we hope to publish at least annually in future, we also appreciate that the infrequency of its appearance prevents it becoming the fluent forum for discourse that Welsh visual culture so desperately needs – but the possibility that it may eventually metamorphose into such is not discounted.

I decided to retain the artists' profiles as a major element, feeling that they not only map the fertile fields of Welsh art and writing about it, but provide too something by way of a 'marketing tool' for practitioners. Attempting to represent fairly the breadth of media, gender, generational difference, geographical spread and artists' subjects, has resulted in obvious omissions which hopefully we will rectify in future. I am always happy to have such omissions brought to my attention, as is the case for new talent in critical writing as much as art.

Another major difficulty in a publication, one having currency beyond Wales, is that one is torn between the need to present our culture's very best aspects (thus also engendering needed self-confidence at home) and reconciling any tendency to hyperbole with the self-criticism for which there is also urgent need. This necessitates a delicate balancing act!

It remains insufficiently acknowledged – though the situation seems to be changing – that visual art, via its various professions, constitutes a net 'giver', both to Welsh society itself and to the image of Wales elsewhere. It is also blindingly obvious to anyone involved that contemporary visual culture in Wales is grossly ill-provided for in terms of many things which are taken for granted elsewhere, even in cultures materially poorer than our own. All visual arts professionals need to continue (and stridently) asserting the tardiness of the National Assembly, civic authorities and certain public agencies, in answering these long-felt infrastructural needs. Our 'wish list' may be long, largely due to lack of past resource and investment, but it is far from unreasonable, or expensive for that matter. Answering it would constitute a serious and well-placed investment. Iwan Bala amplifies this theme in his guest editorial but I cannot forbear mentioning the continued absence of any plausible space in the whole of Wales for the reception of even the medium-scale touring exhibitions which may be seen in almost all large and many small towns in the UK and the rest of Europe.

A famous Swansea poet once wrote

Too many of the artists of Wales spend too much time talking about the position of the artists of Wales. There is only one position for the artist anywhere and that is upright.

Small wonder though: the seeming self-absorption of artists and of those in allied professions is not mere institutionalised hermeticism, but focusses on professional need (appropriate and perfectly understandable in the face of public authorities so substantially devoted to raree-shows, to the neglect of serious infrastructural investment in recognition of the cultural and economic importance of art and artists in Wales). Visual arts professionals are invariably kind in providing platforms and speech-making opportunities at the openings of things like Wales Artist of the Year, Artes Mundi and Wales in Venice, for politicians to associate themselves with the hard-won achievements of those who laboured to establish such things. Politicians who in fact have done little to develop what art and artists need to remedy Wales' sad visual arts infrastructure.

That there has been infrastructural development is true (Oriel Davies, Aberystwyth Arts Centre and forthcoming developments at the Mostyn and

at Ruthin are cases in point). But these are minor tinkerings in comparison with the regularly discharging cornucopias, favouring our colleagues across the border, even when we factor in the advent of a development programme at the Glynn Vivian and the progress of the exciting project for a National Centre for Photography at Margam Castle. Again, that the latter has lumbered along for so long is largely due to the nervousness of public agencies at every level. That they could have discharged their duty of scrutiny with more imagination and embraced the scheme with greater alacrity, whilst encouraging more rapid progress, seems painfully obvious.

On 30th September 2005, the South Wales Echo announced news of a £1.2 billion 'sports village' for Cardiff Bay, to include a 400 foot high 'viewing tower', cost unspecified. One muses that practically all the aspirations for the visual arts in Cardiff could be provided for the cost of the lift in such an edifice and they would certainly deliver the 'regeneration of the area', which is apparently one of the principal justifications for expenditure on the sports village. Interestingly, the same paper (perhaps mindful of the fact the city lost the possibility of a national maritime/industrial museum and hence probably any plausible chance of a Museum of the Nineteenth Century, to Swansea) contains a plea for a 'museum of Cardiff' and one moreover in the (increasingly rebarbative) Old Library. The suggested cost of that was reported as being £4 million.

Rarely do we see anything other than tentativeness and gradualism over our visual arts provision; never the imaginative quantum leap, which so characterises such provision throughout Europe. Can it still be that the humiliation and scar of the Centre for Visual Art remains so deep? Why as a culture do we continue to reinforce clichés about Wales and reserve excitement solely for sport (and maybe music)? Cardiff Council, in particular, is strong on rhetoric and serial tinkering with temporary 'initiatives', none of which seem to come to fruition. Infinitely better provision is found elsewhere in smaller communities with infinitely fewer pretensions.

How Cardiff's artists redeem it; but at what costs to themselves? I don't see the likes of Kim Fielding, Chris Brown and Anthony Shapland (or Swansea's Tim Davies and David Hastie, for that matter) as very likely recipients of MBEs but by God they deserve them! As fascinating and witty as it is to have high art in sea containers, there needs to be far more than informal temporary accommodation for it. High time that the city (and particularly one emancipated from the responsibility of maintaining its own municipal museum and art gallery, a responsibility ubiquitous in every other post-industrial town and city in Britain) claiming to be developing an infrastructure suitable for its status as a capital, grasps the nettle and gets on with delivering the investment that its visual arts community so sorely needs. Otherwise what we have is a sad travesty of a 'capital' and little wonder that its bid for European Capital of Culture failed so miserably. At the time of writing, a re-hang of the National Museum's Galleries is underway, with Archaeology, apparently, being relocated to make room for art. However this change is represented, and the museum does excel at re-imaging itself, this must not be in lieu of the need for discrete, properly designed temporary exhibition space, or another excuse for Cardiff Council being let off the hook!

✳✳✳

I am grateful to Iwan Bala for responding to the challenge of writing the first 'guest editorial', in which he takes up something of the above theme. It is no mean feat to combine analysis, record and polemic so successfully. Similarly, Dr Derrick Price for his perceptive second guest editorial, and for his suggestion for the title of this publication: its appositeness was a 'hole in one'. Although I have tried, it is impossible to thank individually all

those to whom I owe a debt in delivering this publication and the response to my tedious enquiries has been generous indeed, leading me to remark again on the strong element of collegiality amongst most visual arts professionals in Wales. However, an obvious down-side of knowing most of the artists and professional movers and shakers in a culture personally is incestuousness. Happily we are freer than in the past from the worst excesses of institutional nepotism but the very clubbiness of the art scene, particularly marked in Cardiff, although enabling much valuable collaborative practice, is frequently the cause of a loss of critical distance, role confusion amongst art professionals and a cosiness which, as the letters pages of the *Western Mail* teaches us, is as inimical to professional integrity as it is to the strongest art.

There are other consequences: one, as Christopher Coppock pointed out in a *Western Mail* letter exchange, is that the audience for art tends strongly to be mainly other arts professionals, or even other visual arts professionals. In this incestuous situation the general public audience, although invited, to paraphrase Tom Wolfe, receives an invitation which is barely plausible. A recent example of art marketing in Cardiff typified this. In its degree of institutionalisation the preview invitation was barely comprehensible, even to the cognoscenti. No layperson could possibly have known what this expensive and well-financed event actually was about and they couldn't find out either. There was no organiser's address, no phone number, not even a website address. Whilst it is important to 'feed' professionals at a higher level than lay folk and even to organise manifestations devised exclusively for the former, organisers need to ask questions about the nature of the general audience and how to reach and develop it. Funders should be more discriminating and demanding of their applicants in terms of publicity and marketing and of course provide the resources for their appropriate training.

In Wales the dearth of higher education and training in professional arts management, exhibition curation, and even artists' continual professional development, slows the pace of improvement and reinforces the current tendency for artists to metamorphose into curators, commentators and administrators. This, whilst healthy and productive in most cases, does also tend to compound the incestuousness and (what it is most diplomatic to refer to as) lack of critical distance! In such a situation, we must be careful to adhere to the highest ethical standards, or we risk effectively excluding new talent, whether artistic, curatorial or managerial. We all have a responsibility to ensure that fresh talent is nurtured in all professional areas and that space is made, allowing those early in their careers to develop and rise. Any glass ceiling, which cosiness and cronyism effectively conspire to create, perpetuates a situation which has long bedevilled Wales and is as stultifying, boring and inimical to good professional practice as to great art.

There has been considerable interest in how the artists profiled were selected for *Imaging Wales*. In a BBC interview, the excellent Jon Gower even suggested that I had, in identifying so many interesting artists in my first attempt, somehow 'scraped the bottom of the barrel' of talent and that a repetition at the same level of quality would be impossible for many years. You have here evidence that his suggestion was far from the truth. Unless things go seriously wrong, the abundant supply of artist palpabile will continue to give me grief! I am grateful to advertisers, who have recognised the value of supporting this initiative and dipped into budgets which are at best thin. Some obvious candidates have failed in this support and one hopes that, if only for the sake of the comprehensiveness and collegiality for which we are aiming, that this will change in future years. I am

also grateful to the much-maligned Arts Council of Wales, which has grant-aided this publication in a way that is good and healthy in a culture, in the almost certain knowledge that it would receive at least some adverse criticism in return (which it does below). It is to be hoped that the criticism is construed as of the institution, rather than individual personnel.

Often in Wales we feel the Arts Council to be the 'church that hides the sun'. Its expertise in the visual arts has for a long while been pretty thin on the ground and, not untypically for an arts council, it does tend to introspection concerning its doings and serial problems, generally at the expense of those in its constituency. And it certainly has been an epic period for its problems, particularly vis-à-vis the Culture Minister, to be exposed at tedious length, whilst its own, equally bizarre actions have largely escaped adequate scrutiny.

Iwan Bala mentions that hot topic, the arm's-length principle, assiduously maintained by politicians and cultural bureaucrats ever since government arts patronage took its modern form in CEMA, the post-war predecessor of the then Arts Council of Great Britain. But not in Wales, where a previous Culture Minister asserted, with some bravado, that the principle maintained but that the arm was getting shorter! It is shameful that there is not greater distance between government and arts and cultural management and that 'the Assembly' wishes to manage a substantial portfolio of clients directly. As has been said, this is utterly Stalinist but it is also politically provincial and serves to emasculate of the Arts Council itself. It is not simply shameful but sad also that the effective abandonment of the principle should have constituted another Welsh national 'first'. As respected a figure as Professor Sir Christopher Frayling, the Rector of the Royal College and Chair of the Arts Council of England, writes in its annual report of the concern with which political interference in the arts in Wales should be viewed. Normally one would frown at such Saes trespass

on our lawn, but sieges occasion strange bed-fellows. The brouhaha over supposed issues of 'access' fools hardly anyone that aesthetic questions are driving this particular agenda. The result has been that defending the Arts Council of Wales against such political interference verges on the surreal, given its own tendency to dictate to 'client' organisations and effectively dissolve them.

Further to this: whilst valuing the generosity of those who serve voluntarily on arts councils, it also has to be recognised that motivations for doing so are varied. Being on an arts council is not a medal to be worn but a responsibility to be exercised and when artistic liberty is threatened, it becomes a solemn and serious one. Artistic independence is not something to be sacrificed lightly and pusillanimously, for we have in the present a responsibility to the past, as much as the future. Remember that artists of all kinds and those who support them have endured imprisonment and even death to maintain such freedom.

As I write I am mindful of the play 'The Art of Silence' by Cardiff playwright Jennifer Hartley, which toured extensively and has been taken by Ricky Demarco to this year's Edinburgh Festival. It is about, and was performed by, Paraguayan actor-director Emilio Barreto, who spent thirteen years of his life (many of them in solitary confinement) imprisoned by the Stroessner regime, in defence of artistic freedom. In another prison, his wife miscarried their child due to torture, also in defence of artistic freedom. The population of Paraguay is almost exactly the size of that of Wales. In the face of such sacrifice, joshing concerning 'how long or short the arm might be' is frivolous and tasteless. All arts professionals have a duty to refuse to conspire in any erosion of our ability to express ourselves freely and within structures which enhance and defend our ability to do so.

So, sad to have to say, but our duty is not merely to maintain an arts council in Wales unambiguously independent of government but

also to ensure that it, in its turn, does not abuse its function. In this respect current events make actions of the present council difficult to support. In accepting and asserting its arm's-length mandate, it clearly has an ethical duty to exercise its own power similarly. However, its merger proposals for various organisations have had no rational basis whatsoever (and, ironically, have been justified by the arts council on the grounds that "the Assembly requires them!") and instead of persuading, it has used its muscle to enforce. As an example and even accepting that the merger between Cywaith Cymru (Wales' most highly-funded visual arts organisation) and CBAT is a 'good thing' (which I now doubt), the manner of its doing is shameful and certainly far exceeding anything envisaged as a modus operandi for a royal-chartered organisation such as the Arts Council of Wales.

I now find myself asking: can one nation having one public art organisation even be desirable? Surely it makes nonsense of Assembly guidelines on public-sector competitive tendering and effectively establishes a cartel. In terms of competition – cultural as much as commercial – it seems totally undesirable. However, it is the manner of its doing which stinks and the arts and cultural managers involved should ponder their professional and ethical responsibilities. In destabilising, and effectively dissolving, an independent arts trust not complying with the Council's agenda, the arts council has ensured that Wales – again – distinguishes itself by breaking new and in this case highly undesirable, ground. ACW cannot complain that Welsh government is Stalinist and maintain its own credibility when acting in like manner!

It has been announced that the National Assembly is to 'review' the workings of the Arts Council of Wales but one is forced to ask how radical will such a review be; who will do the reviewing, and at what cost? The really important question to be answered is: is our council, one based on the 'British/English' model and strongly responsive to the fashions and fads pioneered at Great Smith Street any longer appropriate for Wales? Surely we need appointees other than ministerial ones to its Chair and Council: at least the latter should elect its own chair from among its membership? And, for all its usefulness in securing independence of government, the Royal Charter might as well be binned. An independent foundation (having national and local government trustees, as well as independent trustees from business and the universities and funding both non-governmental and governmental) might well be a more suitable and modern vehicle for the complexities and dangers of the present situation.

The evident failure, in the short term at least, to assimilate the Arts Council of Wales into the Department of Culture, has not prevented the Minister from instructing the Council to be active in certain areas, or from directing it to fund Artes Mundi at £50,000 p.a. As worthy as the latter is, the Arts Council should exercise its rights and refuse to bow to such interference. As it is, Cywaith Cymru has been without a Director for a year. After significant expenditure on facilitation and brokerage, an appointment to a still nameless new organisation is still far from imminent.

Looking on the brighter side... a conspicuous area of success for the Arts Council, working in tandem with the British Council, continues to be the huge impact that Wales' art and artists are having internationally and the increase in esteem with which our visual culture is regarded abroad, as at home. This has been achieved through Wales Arts International's funding of the Venice Biennale and in particular its grant-aid to independent artists and artists' groups for overseas initiatives. Many of these are mentioned in this publication but many more are not. It has to be said again that recognition of such success, replicated at home, is reflected neither in the block grant given to ACW by government, nor in urgently needed infrastructural developments, which would render us able to consolidate these achievements.

Wales' politicians have a considerable reputation for cultural commitment, which they happily proclaim at the drop of a hat. As far as the visual arts go, it really is time for some serious cash investment.

Hugh Adams, September 2006

As we go to press we hear of the death of Kyffin Williams (1918-2006) sometimes referred to as 'Wales' most famous living artist'. Williams' early achievements (and he did much to influence several generations of art-involved Welsh school-children) have been overshadowed by the considerable Kyffin industry: Menai's answer to Swansea's Dylan, (except that the latter was a truly great Welsh artist). His assembly-line rolled on for far too long, as the acreage of mediocre works on too many Welsh walls attests. He waxed splendidly splenetic in defence of his time-locked, academic church and was implacably against anything he construed as 'modern art'. He became something of a predictable rent-a-quote in his railings against valuable initiatives such as the Wales at the Venice Art Biennale and did much damage anti-collegially, in feeding the tendency of the philistine press to ridicule developments in contemporary art. Although he had his generosities, he was an implacable opponent of the modern: when it became obvious that the new Mostyn Art Gallery would not receive public subsidy if it became the museum-mausoleum of Welsh art, which he envisaged, he strove strenuously to derail it. The Arts Council and others, had a hard job to successfully resist him, as he exerted the influence – only effective amongst the provincial – deriving from his R.A. His eventual knighthood only served to strengthen his arm in this respect. It is to be hoped that any idea of a tribute retrospective will be long-postponed.

Hugh Adams

Eschewed Endorsement

Where to start with Keith Arnatt, one of the most important artists working in Wales today? This is not just because his international reputation was secured in the early Seventies, at the height of Conceptualism and has been maintained since, but because his deliberations with photography have consistently placed an emphasis on contemporary thinking and evolving modes of representation. The complexity of photography's narrative and structural potential is explored in preference to its many seductive formal manifestations. What impresses me most about him, beyond his wicked and intellectually rigorous understanding of the workings of the art form, is that he has always eschewed art world endorsement in favour of a working relationship with photography that is authentic to his theoretical thinking at any one particular time. Put another way, he is one of the few practitioners who has not been influenced by the insidious art world hegemony, which draws divisive distinction between 'the Artist who uses Photography' and the mere Photographer: a distinction which, inevitably and erroneously, devalues the work of a whole host of photographers who have made an immense contribution to debate about pictorial representation in contemporary art.

Arnatt's acute understanding of the politics of representation, embodied by photographic verisimilitude and its story-telling imperative, has enabled him to experiment with the medium in a wholly catholic but consistent way. From his early and hugely arresting serial work SELF BURIAL, which used photography's ability to record the passage of time as a visual conceit, to his humorous typological study of pet owners and their dogs, Arnatt plays with the structural uncertainties of the medium. His MISS GRACE'S LANE series broke new ground in addressing human interventions in the countryside – in the form of detritus –

and preconceptions about the subject of the landscape in Art. And his exquisite, large, formal, close up studies of refuse not only tilted knowingly at painterly abstraction, but 'repackaged' the subject of waste with aesthetic gusto.

Arnatt continues to confound his audience's expectations in relation to his use of photography, only too aware of the diversity and paradoxes which this versatile medium embodies. His art is at once highly authored and progressively inventive and is, in no uncertain terms, charged with a vitality and love of the medium that many younger generation practitioners could productively emulate. That he has chosen to spend the large part of his professional life refining his practice in and around rural Wales, has been very productive for art in Wales and its critical development.

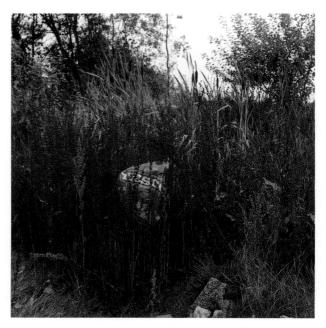

From MISS GRACE'S LANE series

Christopher Coppock

Out of Joint

Performance art, it was suggested recently by one of its leading scholars, emerged from three distinct sources: painting, theatre, and a return to shamanism. All three certainly have had a formative influence on Phil Babot's performance practice. The inspiration which his work derives from shamanism is clearly betrayed by its focus on ordeal, inspiration, trance and healing. It thereby recalls many of the aesthetic and thematic preoccupations of the classic period of performance art in the 1970s, which Babot extends and reworks consistently in an attempt to create moments of great physical intensity and ethical integrity. Despite the resulting formal purity of his actions, or 'live occurrences', as he prefers to call them, there are also strong painterly touches about the manner in which he condenses events to a single, symbolic image, and a finely-tuned theatrical sense of the importance of time.

Durance and endurance are inseparable in the work. Babot's practice is less 'action art' than an art of active stillness. Frequently, a simple gesture is put under pressure through placing it in extreme physical conditions (Babot has had rocks placed on his chest, strings tied to his fingers and suspended himself from ropes) and extending it over hours. The artist's aim is to reach beyond physical pain and out of time to an altered state of consciousness. But to read this as a preoccupation with mere self-reflection is to misunderstand his intentions. Babot sees his role primarily as a communicator. Something is being revealed within the images he creates, for the audience's contemplation over time. The performances often involve the artist literally pointing (emphasised by the use of lines and strings) or intently directing his gaze. Babot's work is thus urging us to see, to pay closer attention, so that we may discover where our world is out of joint.

'Crow (NYC)' (2002)
Performance, Siberia, New York.
Photo: James Melville Thomas

Heike Roms

Paul Beauchamp's series of photographs of quarries and related sites is presented under the title TIMESCAPES, a word coined by sociologist Barbara Adam to talk about those aspects of the environment that contemporary political and economic discourse renders invisible. Some hazards such as deforestation are easily pictured, others (radiation, the build up of chemicals in the soil) operate invisibly over long periods of time. The notion of 'landscape' with its emphasis on what can be seen and what is materially present at the moment of depiction cannot represent these processes. This has led to landscapes being produced and promoted by various governments and large companies as alibis for their damaging activities. TIMESCAPES opposes itself to the notion of landscape, so questioning the significance of the visual. Although many of the photographs are beautifully composed, they are arranged to ask questions about the visible world; they are investigations of the site rather than simple representations. The quarries are places that are usually hidden, but here they are made visible. Connections are drawn between the quarry and the society that produces it. The city of Cardiff is visible over the lip of Garthwood Quarry: the hill has been hollowed out to build that city. The quarry itself belongs both to the natural order and the civilised world: its terraces are both parallel and uneven.

On the one hand 'timescape' opposes itself to landscape; on the other it works to subvert the binarism of nature and culture. Nature has long been pictured as a place of escape from industrialisation and civilisation. In truth there is nowhere on earth, not the mountain tops nor the ocean's depths, that is immune from the effects of human activity. Beauchamp's photographs are a vivid illustration of the extent to which 'natural' and 'cultural' processes have become inextricably intertwined. There is something wild about these places, they are unkempt and as empty of human presence as any moor or mountain and yet the trace of human activity is everywhere to be seen.

The photographs are mostly presented as triptychs. This format allows Beauchamp to intervene in the tradition of landscape photography and painting and question some of its conventions. Most importantly, it fragments the perspectival unity of the scene. The intervals between the photographs introduce a principle of discontinuity into the images that is quite unlike the spectacular totality that many landscapes pursue. The space between the images is like a cinematic jump-cut that reminds the viewer with a jolt that these photographs are material objects. Through the use of reflection, fragmentation and juxtaposition, these photographs bring an important aspect of our relation to the land into focus.

'Garthwood Quarry, Tracks.'

Gathering Everything In

Creating sculpture out of found materials is one of Pat Briggs' principal concerns. It accords with her response to today's consumer-led culture: what is one person's rubbish will be her riches. With a hunter's eye for salvage and recycling, she stalks her quarry in skips and car-boot sales, where discarded materials and unwanted objects are seized upon as trophies which she transforms into sculptural forms. The items are collected, stored, remembered and reconstituted with patience and care, so that random bits of wood, when carved, sanded and polished are grouped together in a rhythmical expression of space and balance. Generic fish shapes, cut from an old oak table, retain their original scratches and surface scores, thus suggesting the watery habitat of fish. Likewise, by cutting into plastic bottles which she slotted together to produce a flower head, a host of floral tributes were created. In terms of shape, form, texture and reflective surface, Briggs explores her concept of recycling in a series of hybrid forms.

These are some of the apparently disparate units which Briggs presented in her 2002 exhibition in Swansea's Mission Gallery. She also included examples of her printmaking: etchings, aquatints and monoprints, while other two-dimensional pieces demonstrated her photographic and life drawing skills. Deciding which works to include in the gallery was her first task, but the organisation and arrangement of these were approached with much more deliberation. She believes that presentation is paramount, that the tangential balance between and behind each exhibit, as each is seen in the context of its neighbour, or alternatively overlapping one another depending on its situation in relation to the position of the viewer, demands the artist's eye in evoking the aesthetic balance of the corporate work. Because the active participation of the viewer is integral to the installation, space itself is a significant element, and that too was positively incorporated into the entire art form.

The show in Swansea was a survey of the evolution of Briggs' sculptural style as well as her enthusiasm for experiment and innovation. After studying art in Leeds, she specialised in sculpture at the Royal College of Art where she became adept at carving in stone and wood, together with modelling clay, making moulds and casting. Fundamental to her entire process is drawing. From the outset she drew from antique casts and from life, maintaining that drawing is her basic means of enquiry. She exercised these skills on lino, which allowed her to carve while simultaneously practising drawing techniques. Her lino prints brought colour and registration into her portfolio, and established her reputation as an acclaimed printmaker. Her latest prints, made from perspex on which she carved the image, are a novel and exciting departure from tradition, thus verifying the enduring originality of this highly talented artist.

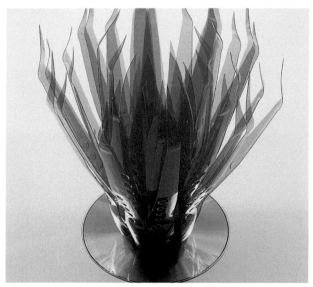

'Single Charm' (2003)
Cut plastic bottle. (Photo: Graham Matthews)

Anne Price-Owen

The Enigmatic Interloper

The nature of Susan Butler's quiet intervention has been to track the movement of paintings in and out of the National Museum of Wales as they were sent away on loan to other museums and galleries for exhibitions, over a twelve month period. In the empty space left by their absence, with only the label of the painting remaining, she would install her work. The nature of the device she introduced is all the more remarkable for being the most commonplace piece of museum furniture: a frame. A frame made strange, by the simplest means, or economical act, arising out of its own nature. And strange indeed it is: one of the most enigmatic objects seen in recent art. A frame resembling that of the missing painting has been cut down to eliminate completely the opening which normally contains the picture.

The result impacts upon the psyche. An extraordinary compression is achieved, a concentration of density, an implosion of the decorative. Absolute symmetry is stressed as the various borders converge on the centre (the cuts at the four corners adding to the sense of recession).

Nothing could express closure more strongly. This great opening, this ancient convention, this window onto an incalculable diversity of worlds, has been closed: such is the effect when the object is seen beside other paintings on the wall. However, it is not only the negative loss of the picture-world, but the positive object-presence achieved from the simple carpenter's logic of this reduction. The frame becomes a sort of casket, taking on a secretive quality. The central part resembles a slot or keyhole into which a key could be inserted to open the box.

[This extract from the essay 'The Enigmatic Interloper' is from the artist's book *Elsewhere*.]

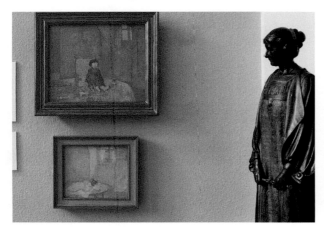

(before) Gwen John 'The Japanese Doll',
lent to Tate Britain September 2004–January 2005

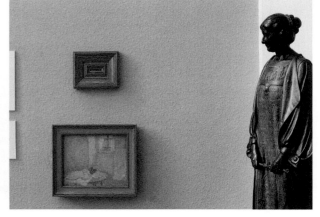

(after) Susan Butler 'After Gwen John: The Japanese Doll'
One of 20 temporary, changing objects appearing in the painting galleries of the National Museum and Galleries of Wales as part of ELSEWHERE, 29 September 2004–15 May 2005.

The Lure of the Local

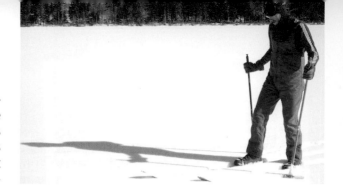

In these times of aggressive American cultural imperialism, in which every place comes to look more and more like every other place, the local has become an endangered species. A response to this has been, across the world and over the past decade, a renewed interest in the idea of psychogeography. First expounded by Ivan Chtcheglov in 1953, psychogeography has, over the past decade or so, grown into a field where sociology, cartography, psychology, local history, philosophy and a plethora of visual arts practice converge. This nexus is also at play in the work of Stefhan Caddick.

Using performance and interventions, Caddick investigates our relationship to the local and to place, exploring the factors that influence the ways we navigate and negotiate our environments. The work often takes the form of a self-imposed task, such as cycling from the South to the North of Wales along a route determined by passers-by who, at Caddick's request for directions, would scribble maps for him to follow. In the snow-covered Laurentian Mountains of Quebec Caddick, like the coureurs des bois (the fur traders nicknamed the 'runners of the woods', who settled there from Europe), was confronted with the problem of how do you get around here? In a lakeside hut surrounded by forest and snow and the occasional cries of wolves, the artist set about making himself a pair of skis, by trial and error, steaming the pine wood to curl the ends. After many days, and with the finished product strapped to his feet, Caddick stepped out across the frozen lake.

The work is left to reside: in story; a couple of photographs and the skis – resting above a fireplace, in a hut, by a lake, in a forest in the snow – in the mountains in Quebec.

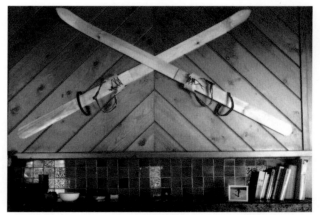

'Everything I know about Skiing' Shown as part of 'Marcheur des Bois' (Walkers of the Woods), Reserve Rouge Matawin Faunique, Quebec (2005)
(top) Hand-made skis, snowshoe foot holders, brooms.
(middle) (detail) Hand-made skis, snowshoe foot holders, brooms, mounted photographs.
(bottom) Hand-made skis, snowshoe foot holders, brooms, mounted photographs.

Sara Rees

Michael Cousin

Rooted in an acceptance of failure, hope springs eternal in the work of Michael Cousin. His practice is eclectic and his influences are far reaching and predominantly outside of the art world; his work is elusive and fleeting, time-based and searching and employs the rhetoric of film without employing a narrative structure and jumps from one association to another.

For as long as I have known his work it seems to have dealt with the structures of fear and hope. It is never didactic, it does not instruct the viewer to think differently; rather it offers an alternative view, a sideways look at perceived normality, that allows the viewer to enter a 'what if..?' place, in between the accepted order of things and a new proposition. It aims to stop things in mid-flow and to allow the viewer to make decisions about what they believe and why. His work carries with it the conviction that, however the world exists, there is always an alternative, another way.

He is disruptive: that is the crux of his practice. He successfully combines the naïvety of a child seeing the world afresh, with a grown-up, stubborn belief that things could be different. He doesn't disrupt to cause anarchy, rather to create a space for contemplation. His work is sometimes comical, sometimes absurd and often has a critical edge to it. He is intent on communicating something wordless, willing the viewer to look at something with new eyes, to experience reality refreshed.

Perhaps he will never articulate exactly what it is he's trying to say, but I am convinced that he will keep on offering us alternatives.

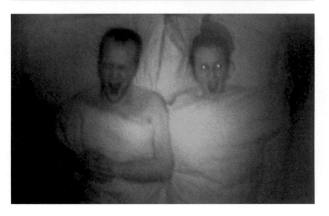

'Fate of the Universe'
'Luminous Fluxus i'
'Sleepers iii'

Anthony Shapland

Eve Dent

An approach or apparition, a receding or liminal being – the image locates us at the threshold. It is at once a passing in to and out of. Between one realm and another, here is an opening, an invitation. The hand(le) is an appeal. It beckons, asking us to enter, to overstep a limit, to transgress a border. We must overcome, force our way against an opposing wind or tide, a contrary sea (threscan). Here is the point at which something hovers, between becoming and cessation (therscold).

The handle is also a question mark: the threshold is the (non-) place of the dialectic. Here is where the abject meets the sublime (sub – under, up to + limen – threshold), where what is base and cast down is yet held most high. In other words, the threshold is a sacred place,[1] which we cross with a tread that tramples.

> I find myself defining threshold, as/Being the geometrical place/Of the comings and goings in my/Father's House.[2]

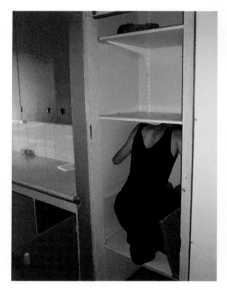

If to haunt is to frequent a place habitually then the house, the home, is always haunted. The home is always *unheimlich* that is uncanny, or unhomely. The German expression *das unheimliche haus* can only be translated in English as a haunted house – a house governed not only by its inhabitants, but by that which is hidden; those unseen visitants. In French, *hantise* (haunting) is commonly used to mean an obsession, a fixed idea, a nagging memory, or a constant fear. Home then is where we are haunted: by desire, obsession, memory, and fear. The house is built on structure, rule and control (*oikos* – economy). The child, who puts her slender arm through the letterbox and opens the house from the outside, disrupts this familial order. As a ghost, she too is an entity with the power to overturn the law of the house. Passing through walls, structures and boundaries similarly evaporate. This existence without boundaries or limits is her spectral domain, indeed her destination (bourn). She exists in parenthesis – not within, not without.

> I'm neither one thing nor the other,/I'm in the middle,/I'm the partition... I don't belong/To either.[3]

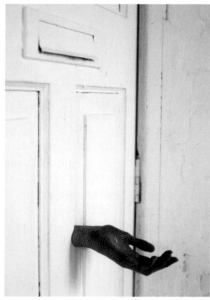

1 Porphyrus, 2AD
2 Michel Barrault
3 Samuel Beckett

'Anchorage 1' (2002)
Photo by Maura Hazelden
'Anchor Series: Kuopio, Finland' (2003)
Photo by Vesa-Matti Nurmi

Sara Rees

Debbie Savage

above: Christian Gräser 'Dome' 2004 (Real Institute)
opposite: Ointment 'Crwydro' 2003 (photo Simon Whitehead)

The Rôle of Artists' Networks in Wales

Networking has unarguably become an integral part of the arts professions. Losing its corporate connotations, it has come to represent a focus for the arts diaspora; a space where ideas can be discussed and professional links developed. It is often ignored (especially by the mainstream press) and taken for granted as an organic process, yet networking plays a fundamental role in development of the arts in Wales and the wider world. A study conducted in 2002 by a-n The Artists Information Company found that 78 percent of UK artists stated that networking was crucial for their own creative practice[1]. The resulting formation of Networking Artists' Networks (NAN) concluded that this high percentage could be attributed to the fact that networks help artists to generate professional exchanges, provide a space for the development of collaborative projects and raise awareness of arts in society[2]. These statements possess a great deal of validity, but fail to illustrate the rich texture of networking activity, and how it has, in many ways, become inextricably linked to the development of artist-led initiatives.

Is there a particularly Welsh dimension to networking? It is commonly suggested that the increase of artist-led activity in Wales during the 1990s directly corresponded with the lack of a responsive funding structure, resulting in the formation of artist-led initiatives such as g39 or Trace Installaction Artspace. This major shift in the means of production also required a new form of communication and, as Chris Brown (development officer of g39 and member of the NAN steering group) suggests, the a-n survey "confirmed that networking activity is also a naturally forming support infrastructure"[3].

Certainly the supportive infrastructure permeates the artistic profession at every level. Initiatives such as Umbrella Arts, a showcase for time-based work, or Coed Hills Rural Artspace (CHRA), a self-sustaining artistic community near Cowbridge, were formed, in part, due to a lack of post-college opportunities:

when we left art college, the sort of experience we had gained working together as a community and in collaboration with each other wasn't there, so we wanted to do something about that.[4]

This kind of support operates on two levels; firstly as a network of peers, learning their trade through each other's trial and error and secondly, as a self-serving network, producing opportunities for themselves and others.

Similarly, Hotel Antelope, an initiative led by Cardiff-based artists Sara Rees and Paul Hurley, established links with St Petersburg that have developed into a series of two-month long residencies in Wales and Russia. These residencies are designed to help mid-career artists progress onto the next level, as Rees explains:

there is a lack of opportunities for emerging artists who are ready to present on an international platform. The residencies will give artists designated time away for the production of new work, and the chance to meet other artists and networks.[5]

These examples indicate that networks can surpass the role of merely being a support structure or space for collaborations, but can be actively exploited to create that "next step". An egalitarian approach, not unique to Wales but certainly missing from many other areas, produces a real feeling that people are working for the "common good", the desire to produce a healthy and vibrant art scene which, in turn, allows artists greater control of their own careers and presents a viable alternative to the gallery system.

This is not to say the gallery system should be considered dictatorial, or as suppressing ideas, but, in comparison to a gallery's more rigid exhibition programme (which in many cases can only accommodate a few artists or shows a year), artist-led initiatives have the ability to be flexible and responsive. For example, Ointment was born from an artist-produced event at a former dairy farm in Pembrokeshire. Artist Simon Whitehead explains:

The decision to continue happened because there was recognition from artists that there were few opportunities in rural west Wales to present contemporary time-based work in response to the economic and cultural changes that were taking place within our rural locale. Most of the artists were growing their work here and then showing in the urban markets – Cardiff, London and beyond. It was felt that we needed to redress the balance and engage with our local communities and sites directly.[6]

Simon Whitehead '2mph' 2002 (photo Pete Bodenham)

In this sense, it becomes an issue of control and choice: using an established framework to present artists with the options of choosing how they would like to work and see their work presented, as well as providing the art audience with consumer choice of how and where they wish to view work. This has obvious impact on the breadth of work being produced in Wales, but also on the sense of 'ownership' people can feel about the work being produced in their local areas. Iwan Williams from Rêl Institiwt / Real Institute (RI), a multidisciplinary arts organisation working in north Wales, feels that:

a lot of art-based projects that were heavily funded were not targeting the local people and were more interested in tourism than local needs. So from early on RI pledged to bring the best art projects to North Wales and not aim at attracting visitors.[7]

The result has been a series of Alternative Film Nights, along with projects such as Roadshow, a 'rock'n'roll' tour of international music, film, performance and stalls playing in Blaenau Ffestiniog and locations in England and Scotland.

Although there are many benefits from working

Graeme Roger 'Hermit' 2004 (Real Institute)

in this grassroots way, it also helps create the picture of a 'fractured landscape' of networks. Many successfully interact over international borders, disciplines, and professions, for example, the Hotel Antelope project, or CHRA, with its emphasis on ecology and biodiversity. Yet there is a noticeable split between the different areas of Wales. Rees suggests this is partly due to topographical factors and the very nature of the networks themselves:

geographical boundaries do have an effect. As many networks are informal and often based in social realms, it makes it difficult to be 'pan-Wales'.[8]

Indeed, it is not uncommon for proposals to begin their lives as a discussion between a group of

like-minded artists taking action to improve their respective situations; a conversation between friends snowballing into a project supported by other artists, volunteers and a sharing of resources.

Although this way of working has its benefits, the informality of networks is a double-edged sword. As Brown believes, "the informal nature of networks is not ideal, but is the most effective way for a group of artists to function"[9] – a notion that is supported by repeated failed attempts to establish an artists' union.

If we take the argument one stage further, however, within the field of artist-led initiatives, we realise that informality is a key to success and may even in fact be fundamental to it. As Phil Babot, artist and pro-active supporter of artist-led activity, says:

> I prefer working on a long-term basis with organisations that can be termed anarchic in their structure ... the more well established artist run initiatives become, the more tied down to the dogma of funding they become, with limitations and criteria to meet. What happens after a while is that some of the artists become full-time administrators and are no longer practising artists. Although they may be on the ball in a certain way, they are not working at a grass roots level as an artist and are no longer really authentically run artist-led initiatives.[10]

However well founded such an argument may be, it is generally accepted that the people who best develop such opportunities must remain artists first and managers second.

With this idea in mind, the virtual world might provide a viable solution as an additional form of communication that can help to overcome financial, geographical and time limitations. For example, a group like Second Wednesday (a network of live artists established to provide a forum for critical discourse in Wales) originally met physically, as its name implies, but now exists mainly as an email group. It is a success in terms of highlighting opportunities and sharing news,

and as technology improves and becomes more readily available, it is increasingly used to make initial contacts and spark collaborations. As Babot explains, one of the ideas discussed at the InFest conference[11] in Canada, was that in developing countries, like Argentina, with a huge geographical compass, political instability and a poor economy, the internet can be used to "create a democratic nexus, a hub, which artists can use to communicate with each other and the rest of the world, free of political censorship". Regardless of the tools available however, the onus is still on the individual to be proactive and make that connection with the wider community. Babot again:

> Geography and perception can create isolation. It is a big, little land and communication and dissemination isn't always easy. But perhaps this is part of our role as artists, to draw the map, join the dots...[12]

Briston Art Librarian 2004 (Real Institute)

Ointment 'ELI(salve)' 2005 (photo Pete Bodenham)

Obviously, the relationship between networks and initiatives is not necessarily mutually dependent (one can survive without the other) but both inhabit the same spaces, feeding each other, deliberately or not, to produce opportunities and develop ideas. Informal structures can, intentionally or unintentionally, mean that some activities become part of local folklore whilst remaining almost invisible to the wider artistic community. This does not make their activities any less valid than those of more overt and successful groups like g39, the Harlech Biennale, or Ointment, but suggests that the versatile nature of artist-led activity will continue to flourish as a "means of creating dialogue and hybridity"[13].

Notes

1 Networking Artists' Networks: Strategic approaches to artists' coordination and collective action – Report on research and pilot programmes 02-04, a-n – The Artists Information Company, July 2004

2 ibid

3 Interview with Chris Brown, 12th May 2005

4 Interview with Rawleigh Clay, 14th May 2005

5 Interview with Sara Rees and Paul Hurley, 11th May 2005

6 Internet interview with Simon Whitehead, 21st May 2005

7 Internet interview with Iwan Williams, 21st May 2005

8 Interview with Sara Rees and Paul Hurley, 11th May 2005

9 Interview with Chris Brown, 12th May 2005

10 Internet interview with Simon Whitehead, 21st May 2005

11 Organised by the Pacific Association of Artist Run Centres (PAARC), InFest was an international gathering of artist run centres held between 25th and 29th February 2004.

12 Internet interview with Simon Whitehead, 21st May 2005

13 ibid

Due to the fluid and sometimes hidden nature of networks, the following list is not exhaustive:

Bloc: has developed from a forum responding to the social, economic and intellectual impact of digital technology to become the agency promoting creative work using computer technology in Wales.
Contact: www.bloc.org.uk

Coed Hills Rural Artspace: an arts organisation committed to sustainable living. Over the past seven years, the group has initiated a number of residencies and developed a sculpture trail that exhibits new works and re-houses others.
Contact: www.coedhills.co.uk

g39: run by practising artists, the gallery works closely with artists, curators, writers and organisations to build a network of support and advocacy, and shows interesting and experimental works from Wales and further afield.
Contact: www.g39.org

Harlech Biennale: organises international artists' residencies with the aim of promoting a cultural understanding between the peoples of the European Community and providing a platform for visual artists in Wales.
Contact: www.harlech-biennale.co.uk

Hotel Antelope: a new initiative that "allows artists to roam between cultures". Through the organisation of two-month residencies, Hotel Antelope aims to produce a worldwide exchange of ideas, opportunities, relationships and networks.
Contact: hotelantelope@hotmail.com

Ointment: an itinerant collective of artists based in west Wales, producing live and interdisciplinary art; events respond to their locale: "constantly aiming to develop a place-sensitive language of ideas and images in rural and agricultural sites".
Contact: www.ointment.org.uk

Rêl Institiwt / Real Institute: a multidisciplinary arts organisation founded in 2000 "to do the great things north Wales deserves". They are perhaps best known for their Alternative Film Nights, but also initiate a range of contemporary art events unconfined by any particular form or tradition. Contact: www.realinstitute.org

tactileBOSCH: primarily artists' studios, tactileBOSCH is also well known for its exhibitions of emerging artists and international collaborations.
Contact: www.tactilebosch.org

trace Installaction Artspace: promotes time-based art and work emerging from this field at a local, national and international level. Contact: www.tracegallery.org

The Welsh Group: a professional group established in 1948 to develop the reputation of Welsh art.

Umbrella Arts: co-founded in 2001 by Michael Murray and Victoria Jane Cooper. The group organises one-off art events to raise the profile of emerging contemporary artists making new work in new contexts.
Contact: www.umbrellaartsgroup.org

56 Group: a society of professional artists that aims to promote Welsh contemporary art. Established in 1956, the group has exhibited in Wales, England, Czechoslovakia, Italy and France.

John Paul Evans

In the 90s, John Paul Evans' human-scale portraits of Action Men – black and white images shot in daylight – were often so subtly organised that at first take one presumed them to be psychological portraits of real people. In Bed Sheet Dreams it is the artist himself who is in action; holding a digital camera at arm's-length as he manoeuvres with a degree of discomfort to fit within the frame. Evans tells me, "the camera is effectively recording a movement of time rather than a moment of time". No further digital manipulation occurs. The artist achieves what looks like a manipulated image through the accidents of the camera. The intense backgrounds result from shooting on a variety of bed sheets. The light source remains daylight, but now colour is a key factor. The Action Men portraits were essentially sculptural; these images are painterly, the colour possessing an astonishing texture. Accident permeates the references the images suggest. The artist spread open on a dark green sheet reminds me of the enigmatic nude in Duchamp's 'Étants Donné', while an almost crucified blur on a yellow sheet evokes Gerhard Richter's 'photographic' paintings. When I think of the artist contorting for the camera, I am reminded of the faces pulled by F.X. Messerschmidt in front of a mirror, which led to 'character heads' of grotesque and 'pathological' intensity (first exhibited in 1793). Are they exorcisms or manifestations of some schizophrenic syndrome?

In Evans' work, the contortion involves the body, not just the face (sometimes no more than a movement, a stain). This gargoyle-like activity is even more enigmatic than Messerschmidt's, whose titles ('A Constipation Sufferer'; 'The Difficult Secret') gave strong, perhaps too specific, clues. Evans' BED SHEET DREAMS are untitled, but share one further irony with Messerschmidt's portrait heads, for these prints are consummately realised, in terms of their colour values, just as Messerschmidt's heads represent the acme of neo-classical skill. Such ironies appeal to dedicated practitioners. Content is subservient to expertise and technical enquiry, as when the master of trompe l'oeil, Gysbrechts, paints the picture of the back of a canvas.

The grotesque, that amalgam of horror and laughter, abject and sublime tensions, has been often utilised to showcase skill. However it is not a term that exhaustively covers these bizarre images. These dreams have a vulnerability. Their general title suggests those involuntary 'maps of Ireland' that are matinal evidence of adolescent stirrings. Some female viewers have remarked on the foetus-like aspect to certain works; a quality that renders them womb-like, the sheet as the caul, the arm umbilically connected to the mothering eye of the camera.

'Green Dream 11'

Anthony Howell

Deep Games

Laura Ford's figures beat paths into our minds by way of their originality and visceral accuracy. They can be seen in an artistic tradition that exploits the fantastical as a seam of truth, from Medieval Last Judgements to the dreamed cosmos of Blake, the fairytale inventions of Ana Maria Pacheco or the potent performances of the late Leigh Bowery – artists' imaginings let loose upon our own imaginations, conjoining dream into what André Breton called 'an absolute reality, a super-reality'.

Ford was born in Cardiff in 1961. Long before studying art at Bath and Chelsea, she was educated within her own fantastical world, growing up in a family of show-people, who ran travelling fairs in south Wales and a funfair at Porthcawl. The childlike boundary of laughter and fear, playing and believing, was professionally exploited all around her. This inheritance seems to condition Ford's works. They possess a humanity seldom seen in contemporary installations, neither constricted by a conceptual device, nor cuttingly ironic, but transcending fashion with a distinctive vision of the corners of the human mind.

The sensations that Ford exploits above all are the stuff of games small boys play, her under-standing of them deepened by observing her own children. In these, pretending is a form of testing, and perhaps a preparation for the normal horrors life can throw at us. Ford's games are most compelling when figures come together, in some adventure or extremity, or are caught up in lonely interdependence – Scott's Antarctic expedition is a major inspiration. She is a startlingly good maker, fooling the eye with her precision in shape and movement. We know these are dummies, yet they are possessed of something real. They remind us that only the spark of life separates each one of us from mere material – particularly poignantly in the soldier figure she calls 'Some Mother's Son'.

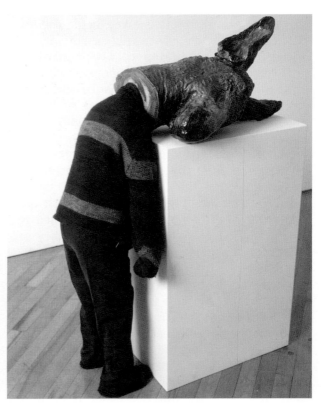

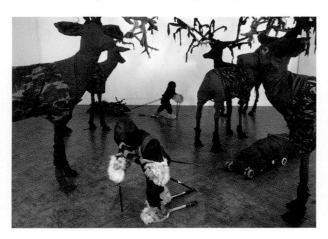

'Stags & Boys' (2002) Installation

'Headthinkers' (2003) Installation

Peter Wakelin

Time, Space and Castlemartin

Arthur Giardelli is of a generation that included Jackson Pollock, Salvador Dalí and Jean Dubuffet. But he is still working, quietly in west Wales. His abstract relief constructions echo the shifting of the seasons, the wind's energy, or the movements of the tide. They are made from evocative found materials, man-made and natural, each of which brings its own history and associations: slates, brasswares, string, sacking, shells, paper.

Giardelli was born in London in 1911. He read Modern Languages at Oxford and attended drawing classes at the Ruskin School. In 1940, he joined the Educational Settlement at Merthyr Tydfil, where he was encouraged to paint by Cedric Morris. After the War he began re-visiting galleries in Paris and Amsterdam: it was Mondrian who was in his mind when he made his first collage of found materials in 1955, simultaneously with the birth of the Arte Povera movement. By the 1960s he was producing intricate and lyrical images with paper, shells and watch parts, often explicitly inspired by his coastal surroundings. The ingenuity of these manipulations was unlike anything that other artists were doing at the time – slicing a brass tap into slivered splays, tearing paper to conjure towers and columns, or organising limpet shells into contours echoing each shell itself. Their distinctive rhythms and harmonies in articulating found materials were paralleled later by artists such as David Nash and Andy Goldsworthy, who could almost be his grandsons.

There is real power in Giardelli's dissection and assembly of the world – his constructions seem to travel on a journey from the baseness of their materials to expressions of the metaphysical. There is a formal rightness to the compositions, and a frequent beauty, but there are deeper meanings too, concerned with time, space and transitory lives.

'Habitations' (1999) ink, paper, limpet shells in wood, 81 x 81cm

'Evening Sea' (1967) brass, wood, damask, pigment 91 x 91cm

Peter Wakelin

Paul Granjon

Paul Granjon's robotic creations are evocative of the images of chimera found in medieval bestiaries – collections of allegorical descriptions of animals, both real and fabulous, that illustrated what was the correct way to behave from a Christian perspective. Mythical creatures were depicted as amalgamations of body parts from different animals, for example, the manticore, which had a man's face, a lion's body and a scorpion's stinger. These gilded pictures, sometimes humorous, were intended to illuminate, both literally and metaphorically, the accompanying text and draw out its moral significance:

> to improve the minds of ordinary people, in such a way that the soul will at least perceive physically things which it has difficulty grasping mentally: that what they have difficulty comprehending with their ears, they will perceive with their eyes. ('The Aberdeen Bestiary', Aberdeen MS 24)

Granjon creates three dimensional, behaving automata, tinkering them together from children's toys, other consumer goods and electronic components. In his 'bestiary' we find creatures such as: Fluffy Tamagotchi (teddy bear material, Chicco toy TV set, BBC microcomputer and some sensors), which can sing, wave its arms around and shit blue turds; the Cybernetic Parrot Sausage (made from a wurst and a cannibalised toy parrot), which repeats recorded phrases while partially rotating; and the male and female Sex Robots, the latest and most technically advanced of his machines, that seek each other out and mechanically couple until electronic orgasm occurs. These works address a post-Darwinian, post-industrial Western society, in which nature no longer exemplifies a divine order and where our lives are more influenced by Moore's – rather than God's – Law: a place in which we are free to consume – as long as we work more hours a day than feudal serfs. Granjon's alter-ego, RobotHead,

a programmable robotic mask that he uses in performances, explains its role as being "to help you humans face the activities of everyday life despite our feelings of the moment". The artist does not have a doomsday vision of technology accelerating out of control, rather, his work engages with it hands-on, reveals its workings and celebrates a world that can produce such fabulously absurd automata. In the words of RobotHead: "Rororo, headheadhead, Boot me up, don't worry, Put me on, c'est parti".

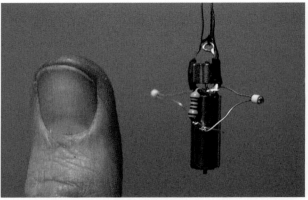

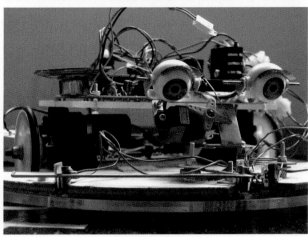

(top) Miniature robotic bird (2003)
(bottom) Smartbot during construction (2005)

Jon Bird

The Poetics of the Ordinary

Though Andy Hazell studied fine art at the Slade, his work is more often displayed in crafts galleries. This is probably because his hand-operated tabletop automata, made from scrap tin, assume the scale and playful quality of handmade toys. But Hazell is an 'ideas' man as much as a maker, with something of the 'Boys' Own' gadget constructor about him. Whether artist or craftsperson, the eccentrically ingenious nature of his practice places him in the steps of British artist-inventors such as Rowland Emmett and Bruce Lacey.

Hazell will opportunistically employ anything from film or neon to rubberstamps. His work can be pocket sized, or too big to fit inside a gallery, as his many large-scale commissions for public spaces attest. Hazell confounds our expectations of physical scale – witness the miniaturised Forth Bridge that he has placed over a drainage ditch near York, or his monolithic steel fingerprint outside Swansea Central Police Station.

Beyond their immediately engaging qualities, Hazell's objects reflect upon political matters. His travels over the years have made a significant impact on his world view. He has observed first-hand the effect of Western capitalism and its profligate waste on the 'third world', and cannot evade the feeling that we are all "watching television while Rome burns". He photographs the environmental marginalia of disparate cultures (a wayside shrine in India; road cones in Norway) and sooner or later their existence is registered in his work.

But some of the subjects that recur in Hazell's work are very British and old-fashioned, like garden sheds, magazine racks, standard lamps, radiograms. However, he celebrates not nostalgia, but the simple, socially cohesive secular rituals that we are in danger of losing. Although he would hate to sound pretentious about it, the poetics of the ordinary is what Hazell is about.

'Funnel and Smoke'

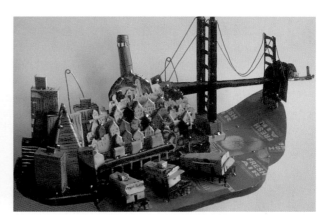

'San Francisco'

David Briers

Rozanne Hawksley

The 1988 SUBVERSIVE STITCH exhibition at Manchester's Corner House Gallery is today recognised as a seminal point in the history of contemporary textile practice. Rozanne Hawksley was one of its stars. Nearly two decades on, she is today known as one of the UK's great textile art innovators whose work lies far beyond simple categories. Her best-known piece 'Pale Armistice', is now in the permanent collection of the Imperial War Museum and has been widely exhibited. Her installation 'A Treaty will shortly be signed', was originally devised for the Mission Gallery in Swansea, then toured the UK and Ireland over 2001. In common with other pieces, both railed against the iniquity of those who conspire to wage war, but in very different ways. 'Pale Armistice', a quiet, reflective wreath made from pale grey gloves imparts its message with subtle dignity. 'Treaty' is a visceral tableaux of bones, blood and rage.

A recent piece 'For Alice Hunter...' was inspired by the life experience of her grandmother, an outworker for one of the (then many) naval tailors in Portsmouth. It recounts a sailor's life through her piece-work on hundreds of collars, and subtly draws on the realities of naval life at that time, such as the suture patterns a surgeon would have used to close wounds. The resulting tableau charts the passage of time and the arc of a sailor's life, from the making of his collar to his shroud, and final resting place deep in the ocean. Assembled before the onlooker they form a quiet altar, a contemporary relic, a contemplative shrine to the perils of life at sea, and a celebration of the invisible seamstresses and the sailors who were buried anonymously at sea in the garments they made.

Rich in allegorical references, her work charts an odyssey encompassing the universal and intensely personal. Recurrent themes are the fragility of the human condition and the immorality of war. There is fascination with revealing the darker, macabre even, side of existence, with reinterpreting centuries-old memento mori, but within a unique and life-affirming embrace. She mistrusts the glib certainty of authority, and feels profound rage against loss and injustice. She questions Catholicism, yet retains a love of ritual. These tensions underpin her creativity. They are manifest throughout her work, and in her messages and strategies to engage and draw us in – a combination of opulence, horror, 'decadence' and theatre. All are vehicles for her messages, which can be as subtle as faint music from long ago, or can strike with visceral power. An exhibition of her work will stimulate, provoke, inspire and mystify.

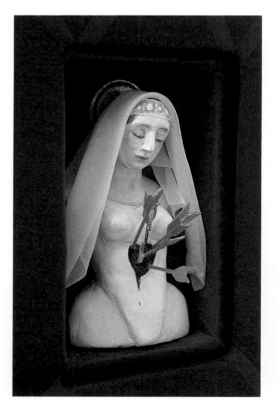

'Madonna – Our Lady of the Seven Sorrows' (2002)

Philip Hughes

Untruthful Relationships

The work of Richard Higlett comprises two strands: firstly, the creation of 'untruths'; secondly the relationship between image and text, fact and fiction. In THE TRUTH'S NOT OUT THERE Higlett has photographed light sources with a cheap digital camera. In its failure to accurately capture an image of the light, the camera produces beautiful aberrations that echo celestial phenomena. While these images of cosmic banality have a certain melancholic humour, they also raise questions about the ascendancy of the visual in our culture. Until Newton pierced his eye with a bodkin, we believed that the human body was a lighthouse, the illuminated world streaming from our eyes. Science now says otherwise but in terms of the relationship between seeing and believing, vision and truth/reality, we are lighthouses. THE TRUTH'S NOT OUT THERE reminds us of the limits of knowledge, and the vast spaces of the imagination / mind or cosmos that will always elude us. Higlett is also concerned with the question of what it means to be an artist. To his mind, the world is in a constant process of creation and there is not a point when the artist, or anyone else, is or is not creating. In a recent work exhibited in Montréal, a simply drawn animation was projected onto the gallery wall above a publication display. Barely visible, two clasped hands twiddle their thumbs, apparently ad infinitum. Comically imbuing the wall with consciousness, the twiddling thumbs are not, as we might think, a symbol of idle boredom. Rather, each thumb, left and right, engages the opposite side of the brain and in rotation form a kind of generator that fires up the mind. Higlett thus presents us with the overlooked but crucial moment before the creative act, the a priori in place of the art object.

'Before' 1 hour looped wall projection, B312 Gallery, Montréal

'In the neighbourhood' Digital Photograph

Sara Rees

Elegiac Elisions

Hicks-Jenkins has emerged in recent years as one of the most powerful figurative painters in Wales. His pictures are strongly structured with echoes of early Modernism in their organisation of broken planes. They are poetic reveries in which we encounter mythical demons, beasts, modern men and ancient Welsh-born saints engaged, some-times violently, in struggles which reflect the artist's own emotional and spiritual journeys. There is an ever-present sense of the dramatic – not surprisingly. Clive had a successful interna-tional career as a choreographer, stage-director and theatre designer before turning his back on the stage and retreating to his Welsh homeland in the late 1980s, at the age of 37. He found a humble job as assistant custodian at Tretower Court in a beautiful valley leading into the heart of the Black Mountains. There he worked out a new direction in life, turning away from perfor-mance and exploring painting for the first time. Clive first focused his attention on the landscape around Tretower, and then used that as a back-drop in which to place imagery which reverberated within his own imagination. He had fled from the theatre at a time when AIDS had begun to deci-mate his generation of talents, and a terrible sense of mortality pervades his early work. In 1999 he embarked on a series of large pictures, created mainly in dark conté crayon, using as a central image the Mari Lwyd, a figure from south Welsh folk custom with horse-skull head and sheeted body. The sombreness of these pictures reflects not only Clive's concerns about the theatre he had turned away from, but his experiences nursing his dying father while working on the series. The pictures "fused illustrations of moments of intimacy, recalled with care and ten-derness, with images of dreams, visions and long-remembered places, in a landscape of grief and renewal", wrote Michael Tooby. These elegiac works were followed by an equally powerful series painted mainly in acrylic on panels, THE TEMPTATIONS OF SOLITUDE, inspired by a fifteenth-century devotional panel depicting the Lives of the Desert Fathers. Here we see his devils, angels and fantastic beasts in a south Wales landscape ravaged by industrialism.

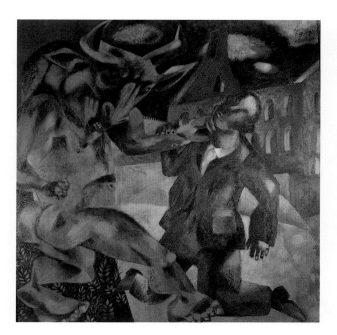

'Attacked by a Demon' (2002) acrylic on arches 55 x 55cm

Iwan Bala

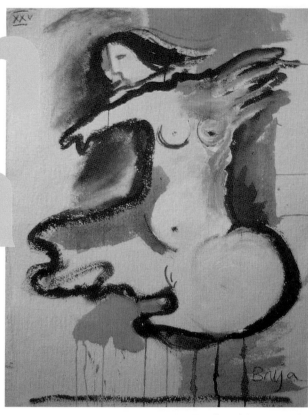

Hon XXV (2005) by Iwan Bala
Mixed media on handmade khadi paper 75x55
One in a series of forty

Take Me Some- where Good

The aim of a yearbook is to review the art and the artists prominent in the previous year, to highlight conditions and events and to foster discourse and dissemination. In this first venture, and bearing in mind that it follows on from Hugh Adams' *Imaging Wales* of 2003, in which a historic context was outlined, I hope to cast an eye over the scene in Wales as it stands. I can only offer a subjective impression, and (unavoidably) a polemic; both of which are confined by my allotted space and, of course, by the limits of my knowledge.

"Take me somewhere good" is the desperate plea in Ed Thomas' drama, *Song from a Forgotten City*.[1] Appropriated with little or no sense of irony by Cardiff's elected representatives (or their PR people at least) these words appeared on Cardiff's publicity material in its bid to become European Capital of Culture in 2008. Cardiff lost to Liverpool, a city once touted with some justification as 'the capital of north Wales' and one embarked on an even more urgent and ambitious redevelopment and re-imagining than Cardiff. Thomas' rhetoric suggests the possibility of imagining yourself into a better place, by desire alone: dream impossible dreams, create new myths and make them into reality. It's ironic that Cardiff's marketing team decided to appropriate the words of a hopeless dreamer (not the playwright but his character) as if they were descriptive, as if this 'good place' they referred to actually existed and that the place was Cardiff. Not for the first time in Wales' history, the rhetoric is not backed up by political reality. Imagination here knows no bounds; political vision however, is in short supply.

The request is not for a ticket out of here, as it often was in the past, but a plea to make this place better. It is directed to those whom Thomas has called the mythmakers; the artists, poets, playwrights and film-makers, the architects, the musicians. All these are the makers of 'expressive culture', and expressive culture lays the foundations for 'somewhere good'.

In order to achieve this, individual lives must be engaged in vital and meaningful projects and not be left to vegetate in real and metaphoric by-pass towns. Arguably, the dreaming itself becomes the project, dreaming, spinning words, and making art. This art then awakens the imagination of the wider community. But it takes more than inventive words to achieve this, and certainly a lot more than the glib and out of context appropriation of a writer's words for short-term political gain. Real support, political and financial, coupled with respect for the artist's role in society, is needed to encourage the true flowering of expressive culture. Art must not become a meaningless word in a political manifesto, or be reduced to ornamentation for new building; nor should it be seen as some branch of the social services.

Art of the visual kind is increasingly happening. Creative people no longer move away to pursue their careers and others come here precisely in order to create. Six years into a new millennium it seems possible for more artists than ever before to make some kind of a living out of art. It's often a case of too much to write about, and not enough people writing about it, too much to see and experience and not enough time to do it all justice. Much of the activity that goes on passes unrecorded: exhibitions, 'live art' performances, conferences, seminars and meetings, street exhibitions, publications, recitations, video projections, new artists' groups. There is bluster and bombast, moaning and bitching, but mostly a considerable amount of genuine achievement and, as always, critics of it. The visual arts are more vibrant and various and present than ever before in this Wales. Hugh Adams refers in his foreword to the tendency of a small artworld to be incestuous. But the artworld of Wales is a world with many worlds within it, worlds that often never meet. There are different artists and art forms, several generations and antipathetic concerns. Each group has its own constituent audience, its supporters, venues and critics. The gamut runs from Kyffin Williams to Bedwyr Williams, with many points in between. It

Photograph by David Hurn

might be that certain groups practising certain art forms seem more favoured by the givers of public funds than others. But then others are more favoured by private collectors, and a great many make work geared solely to that market, even though a recent survey in the UK found that 30 percent of artists seeking to live by sale of work alone, earned less than £5,000 a year.

Visual Art is an integral part of a whole and wider culture; unfortunately such a viewpoint is seldom encouraged in inward-looking cliques making self-referential art. Should artists consider the convergent developments in theatre, literature and film in Wales, even, god forbid, politics – and absorb this cultural information – they would realise how individual creativity, actions and performances contribute to a remodelling of our own place and time, a constant imaging and a re-imaging. Artists like Tim Davies, David Garner,

Eddie Ladd, André Stitt and Marc Rees, to name but a few, prove that such cultural information, suitably digested, becomes the source of new, relevant and 'embedded' art. There is opportunity to explore identity, roots and the shifting fabric of our communities. New cultures, new communities, which have established themselves in Wales over the past century, have yet to find a voice. Where (beyond the energetic Butetown History and Art Museum) are Muslim and Afro-Caribbean cultures represented? Artists propose alternative societies and ways of being, new dynamics: that 'another world is possible' is evident, in the communal environment of Coed Hills Rural Art Space and in the cross fertilisation of art forms in the Caerdroia project, near Llanrwst.

Respect, opportunity, critical attention, proper funding, these head a long list that Cywaith Cymru's What Artists Need seminars, held across

Wales, highlighted. Perhaps this 'wish list' is not as wildly extravagant as the graffiti that used to grace the railway embankment of Bute Street in Cardiff Bay demanding an Independent Tropical Wales, and yet, they signify an equally unlikely climate change. Individual artists' determination and perseverance have realised improbable dreams that have given birth to events that help shape a potentially vigorous – if not 'tropical', then certainly confident – Wales art world: Wales at the Venice Biennale and the Artes Mundi International Art Prize are the most obvious examples.

Concern is expressed about the financial commitment made to such major 'high profile' events. Can we keep it up? Do 'local' initiatives suffer as a consequence? How can we assess the benefits of the Artes Mundi Prize (cost: the prize of £40,000 itself, plus its administration and that of associated events) and of Wales' second showing at the Venice Biennale (cost: £320,000, all inclusive)? Individual artists have certainly benefited and received offers of further exhibitions internationally on the basis of their appearance in Venice, but how do these events benefit the wider art constituency and Wales' reputation abroad? Do such events form part of a considered and planned strategy, or are they isolated initiatives, cobbled together in the euphoria of devolution and perhaps, as nation-building extravaganzas? Does government funding (via the Arts Council, or worse, directly from the Culture Ministry) actually promote a sanitised 'official' art, art which consequently gets marginalised?

Wales at Venice and Artes Mundi are both essential elements in the holistic order of Wales' art world but they are only part of the jigsaw. Let's not forget the need to create and sustain a market for artists' work at home, as well as abroad. Commercial galleries are crucially important; supply and demand goes on in the real world, beyond the confines and protected environment of state-funded art. Of course, we know art is not simply a commodity to adorn walls: art can address issues and involve people. When Joseph Beuys famously said; "Everyone is an artist", he didn't necessarily mean that everyone is a producer of art objects but that everyone can be involved in the creation of meaning, whether they see the kitsch sentimentality of Jack Vettriano's work as the pinnacle of artistic sophistication, or Tracy Emin's dirty washing (to mention but two tabloid favourites). It is, however, true, that making art is no longer the privileged occupation of narrowly trained middle-class aspirants. It's an open and contingent space, as we are told, where – in theory – everything that's done that cannot be termed anything else, is art. Art practice moves off the plinth and out of the frame, but also away from obvious reference to the 'visual' and into such areas as archiving, text, mathematics and even, in Jennie Savage's case, radio broadcasting. Movement artist Simon Whitehead's performed 'walks' are, in collaboration with sound artist Barnaby Oliver, reconstructed and presented as live performance. Any arena in which the artist can physically and conceptually move can become the artist's territory. When in that territory, he or she is not an archivist, a mathematician, or a pedestrian but (still) an artist.

Cultural expression is now couched in terms of hybridity, where performance and live art, theatre, cabaret and film-making, the sciences, architecture, sound and poetry; all become equal players, reconciled and made compatible in a new project, and it's called 'art' at the end. That's the theory. This reconfigured artworld can be confusing and is often alienating to the traditional audience. There is a perceived over-emphasis in public galleries on certain kinds of art; to the detriment of other more traditional but equally deserving, continuing practices. This then is a setting rife for contention. In a recent publication *The End of Art*,[2] Donald Kuspit argues that art has lost its aesthetic import and has been replaced by 'postart', in which the banal is elevated over the enigmatic, the scatological over the sacred, cleverness over creativity. That is

surely a view held by some and one that is widely promoted. The art critic Suzi Gablik[3] claims that the art world has bifurcated into two completely different aesthetic paradigms, each differing sharply in its view about the meaning and purpose of art. She identifies the division between those who 'continue' to proclaim the self-sufficiency and separateness of art from social and moral issues and those artists who want art to have some worthy agenda outside of itself, and a socially redeeming purpose. This 'purpose' often leads the artist to abandon the more traditional, artfully constructed, wall-hung, or plinth-mounted, 'object', which is put up for sale in the gallery, in favour of more communal, activist art. It is not so easy to categorise, or define the artist, let alone bring them to a wider audience.

Buildings are obvious places to view art, traditionally at any rate. The impressive new Wales Millennium Centre has become a visual landmark in Cardiff Bay, and, designed by Welsh architect Jonathan Adams, is a landmark also in the poetic self-image of a devolved Wales. It seems though, that the provision made for visual art – on two hastily requisitioned balconies – has been an afterthought. Across Wales, Lottery-funded developments abound. There are the extension to Oriel Mostyn; Galeri, Caernarfon, designed by Richard Murphy; Newport's Riverside Arts Centre; the National Waterfront Museum, Swansea and a refurbished Oriel Davies in Newtown. On a journey from Cardiff to Caernarfon, there is a choice of art oases to pause at: the Cynon Valley Museum, Aberdare; Brecon Museum; Aberystwyth Arts Centre and Y Tabernacl, the Museum of Modern Art in Machynlleth. Contemporary art is physically very apparent in Wales, but how well embedded is it psychologically?

The Artes Mundi prize and Wales at the Venice Biennale stand like the giants Gog and Magog, twin peaks in the attempt to prove that art is important in Wales. Both emerged following pressure from artists, William Wilkins in the former case, Catrin Webster and others in the latter. Important though these events are, let us not overlook equally significant long-term international initiatives that have somewhat less visibility. *Imaging Wales* described the initiatives of individual artists like Harvey Hood and Richard Cox, who opened up dialogue and exchange with artists from abroad, thereby creating opportunities for others. In this publication, Debbie Savage describes the extent of Welsh artists' networks mentioning The Artists' Project, tactileBOSCH, Harlech Biennale, The Welsh Group and others. Galleries too, such as Ffotogallery, Oriel Mostyn, and g39, remain highly active in this field. Frequently supported by Wales Arts International, administering Arts Council of Wales and British Council funds, most of our organisations have sent representatives abroad; have welcomed visiting artists and curators in return, establishing extensive overseas networks in the process.

In comparison, Wales at Venice ran the risk of becoming separated from the realities of the art community in Wales. But with such initiatives as Bedwyr Williams' Venice residency in 2005, links back into Wales seem more possible. Biennale are important for the art community, for the perception abroad of Wales' commitment to art and for the cognoscenti, who travel to la Serenissima to view the exhibition and enjoy the festival and the location. The overall impression I get is that Welsh artists – of all generations – now relate themselves more to Wales than formerly: it's like having, for the first time, a team to play for and certainly to cheer on!

For the majority of the population though, art is encountered nearer home – on a community level, through small galleries, chance encounters, 'public art', residencies and projects and through the endeavours of places like Narberth's Oriel Q, Ruthin Craft Centre, or Oriel Plas Glyn y Weddw near Pwllheli. There is an increasing awareness and appreciation of contemporary art and all these developments are dependent on grass-roots toil,

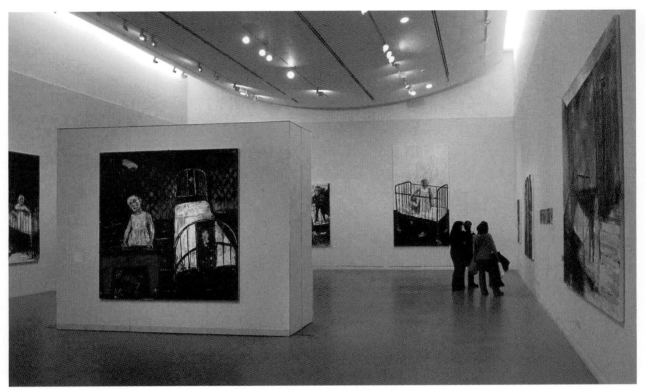

Shani Rhys James 'The Black Cot' installation view, Aberystwyth Arts Centre (2004)

and connection at street level. Flagship enterprises that are 'flown in' like spaceships from elsewhere are left marooned, as the expiry of Cardiff's Centre for Visual Art in its first year abundantly testified.

As Hugh Adams points out, there is still no dedicated space for the larger-scale touring exhibitions of contemporary art, or for showcasing art from Wales in the capital city. Such provision is essential for contextualisation and hence understanding of our own art, let alone that of artists from elsewhere. The network of strategically placed art centres that runs through Wales is excellent: offering a variety of programmes, it gives access to contemporary art and craft throughout the country. However, where in 2004 Shani Rhys James' work was shown to its best advantage was at Aberystwyth Arts Centre: the beautiful and lofty

new space allowed the paintings to breathe and, for the first time, accorded them the reverential space they deserved. It takes a large space, properly lit, to allow such paintings to become fully activated. As a nation we deserve access to a series of such spaces within one building, in a well-funded national institution for contemporary art. Any decent-sized European city, regional centre, let alone capital, can boast a purpose-built contemporary gallery to showcase a collection and touring exhibitions of international art. Such provision is the norm and state funding of these temples of art is based on the understanding that Art attracts people, people bring investment, and that consequently culture and tourism thrive.

Following the Eisteddfod of 2004, there was a threat and consternation over the continuance of

an Arts and Crafts pavilion at the National Eisteddfod, something we had all assumed was sufficiently valued and entrenched to endure. Thankfully, the situation was remedied by 2005 – through some astute manoeuvring and the intervention of the Arts Council of Wales. Re-named Y Lle Celf (The Visual Arts Pavilion), Wales' most prestigious open exhibition has been reprieved. Over the last fifteen years it has consistently exhibited the leading contemporary art of Wales, raised debate and generally infuriated and excited in turn. More importantly, it has presented the visual arts in the context of Welsh-language Wales. During the week-long festival, art is encountered by a wide cross-section of the population (over 40,000 visited Y Lle Celf in 2005) and hence has more impact and receives a more varied and publicised response than usual.

Whilst such events raise public awareness and appetite at home, Wales' artists are increasingly visible in the international arena. Five artists travelled to Mexico for IDENTIDADES 2005, others to Vilnius, and there is a continuing Quebec/Cymru exchange project supported by Wales Arts International and the Quebec Government Office in the UK; the Sao Paulo Biennale had a Welsh presence in 2004; TO JE WALES (It's Wales) was a feast of art from Wales, presented by the British Council in the Czech Republic in 2005-06; Richard Powell's MOTH, shown at Ffotogallery, involved working between Cardiff airport and the Cyprus end of one of its air routes and was helped by an Artists' Good Ideas project, funded by Cywaith Cymru; André Stitt was ceremonially presented with the keys to the city of Manila during a working visit in the summer of 2005; glass artist Catrin Jones went to Iceland; Paul Emmanuel is working with an Australian choreographer and a Chinese dancer following a residency in Taiwan; in October 2005 The Artists' Project, with European funding, collaborated on networked events in Wales and abroad...

Almost all such initiatives are artist-led and,

IDENTIDADES, Mexico (2005). Far left, Jennie Savage; second from right, Lowri Davies

although supported by organisations like Cywaith Cymru, CBAT, Wales Arts International and the Arts Council of Wales, they come not from the centre, or indeed from any one organisation but from every part of Wales. Reciprocation is a different story and often done on a shoestring, which means that artists coming to Wales are given less facilities, time and attention than they deserve. This situation should be remedied, for there are imbalances and on the whole Welsh artists experience better provision abroad than we can offer. The lack in the whole of Wales of as basic a provision as a plausible residential studio for visiting artists is shameful.

Despite the eagerness of artists to come here from all over the world to exhibit, there remains a perception here that Wales is 'peripheral'. Supplanting the postcolonial notion of 'centre' and 'periphery', with the more equitable notion of the 'negotiated space' (hinted at in the first Artes Mundi), might merely be a comforting piece of rhetoric. Wales, geographically peripheral in European terms, might appear to benefit from such a concept. It is a small yet unique entity on the cultural map of the world (and one that has always 'punched above its weight', we like to think). Might we most appropriately make links

with other similar-minded 'peripheral' areas, like Estonia, Lithuania or Quebec? But our artists are an ambitious lot and would just as soon be operating in the epicentres of art (New York, London, Beijing, anyone?). Problematically, within Wales itself, Cardiff is increasingly viewed as too much the 'centre', whilst the rest of Wales becomes the 'periphery'.

Despite internet networking, cities still hold sway; the curator-dominated metropolitan mainstream has the upper hand and access to the mainstream more often than not necessitates the 'mainstreaming' of the artist. Conversations with the shortlisted artists for Artes Mundi emphasised the fact that winning would change little in their already well-financed careers. After all, their very 'visibility' to the selectors stemmed from their already being represented by international galleries, or having achieved 'Biennale recognition': their work was already prominent. A significant caveat would except the two Welsh artists shortlisted so far: Tim Davies and Sue Williams. Their work is in all senses equal to that of their fellow exhibitors but would not have been seen by the selectors had they not been encouraged to visit studios of artists in Wales. Neither Tim Davies nor Sue Williams is represented by a gallery financing their work; neither indulges in a trans-continental lifestyle, busily fulfilling exhibition obligations the world over. Both have to gain their niche in the international art world and one wonders whether Artes Mundi will project them onto it? The reality is that for that kind of success their only recourse would be to leave Wales, which would leave us much impoverished. So much for eradicating notions of 'centre' and 'periphery': it remains a fact that most artists who 'succeed' do so by abandoning peripheral locations. Bethan Huws', Cerith Wyn Evans' and Laura Ford's modi operandi are more the rule than that of either Shani Rhys James, or David Nash.

Of the new-found popularity of contemporary art in Wales, we can find irrefutable proof in the viewing figures (which reached 70,000), for Artes Mundi, 2004 – the largest attendance at any recent exhibition in the National Museum, Cardiff (the Augustus and Gwen John exhibition received 37,000 visits). No doubt, such statistics emboldened the museum to take steps towards an invigorated and soon to be extended, display of art. Further developments towards establishing the Cathays Park site as a National Gallery are to follow, with, we are told, the possibility of a new extension.

Evidently, contemporary art is not, as the tabloids would have it, beyond the ken of 'ordinary people'. However, there is a growing tendency towards censorship of various kinds that undermines individual artists' freedom of expression. These dangers have been brought into sharp relief (as Hugh Adams writes) by the absorption of some of the Arts Council of Wales' responsibilities by the National Assembly. Where is the arm's-length principle, which has been the proudest boast of successive British arts councils since their inception in 1945? Can it, and ought it, be eradicated through one ministerial decision? Arm's-length assumes a motor behind the arm, free from political dogma. Although the wisdom of the Arts Council has sometimes been questionable, would anyone want the civil servants to take over?

The arm's-length principle is sufficient to secure a reasonable degree of independence and ethical probity. Any consideration of further absorption of arts administration by the national civil service must take into account the dangers of political pressure, including the need to please the voters, with the inevitable concomitant tendency towards 'populism'.

The Welsh Conservative culture spokeswoman, Lisa Francis, in the *Western Mail*, accused Culture Minister Alun Pugh of heading "a Politburo of Political Correctness", in response to the news of the 'sacking' of the Arts Council of Wales' Chair, Geraint Talfan Davies. She went on to describe

the process as "the Stalinisation of the arts". The minister's response was – predictably – to tout his responsibility to "spread public money around all Welsh communities" and cite "elitism" yet again, ignoring the fact that the policy of 'art for all' is already high on the Arts Council's agenda. The most intelligent press response came from the editor of *Golwg*, the Welsh language weekly, commenting on the need for art to be free of artificial 'government targets' set to convince an electorate that all the right buttons are being pressed – in this case 'access to art'. This has all to do with political targets and nothing to do with art in its true essence.

Self-censorship by artists with eyes on government-awarded grants is a danger; already there are signs that censorship in art galleries (often at the behest of, or in fear of, the tabloid media) is growing. Political correctness, the fear of causing offence, means that skewed interpretations are made and works withdrawn or not considered at all. The 'offence' that such art might cause to fundamentalist religious groups, or the intolerant 'politically correct', is often either merely imagined, or cynically orchestrated. Art quite often 'upsets' people, it is one of its functions – to challenge opinions, orthodoxies and to prise open closed minds.

Meanwhile, despite devolution, a freeze by Westminster on the Arts Council of England's budget, along with diminishing Lottery capital investment, means that – due to the relationship of the Lottery with arts and heritage distributors – there is a diminished purse in Wales. Fewer developments will be supported and the momentum achieved over the last five years slows and shrinks. The National Assembly could, should it have the vision, still remedy the situation. It might see that, even if literature in our two languages is still credited as the true map of the heart of the nation, then surely visual art must be its sub-conscious?

By now it ought to be apparent that visual artists are also engaged in metaphorically 'writing

the nation'. The artist and writer Osi Rhys Osmond has said that in the past, Wales' preachers were its painters[4]. In the absence of brushes, paint or canvas, they created a verbal version of grand symbolic vistas, of history and of culture. Some painters might well be preachers still, but what today's artists have to say is surely less mediated by dogma, less decorative and illustrative than Wales' past art, and it may be that the work of contemporary artists can say much more about the national state of mind because of that. The artists representing Wales in Venice in 2005 certainly seemed to embody a strong element of the idiosyncratic in their work, using humour in a deadpan way, utilising all sorts of bits and leftover pieces, and building new imaginative constructs. Yet, allied with the superficial jokiness was a serious, poetic reverie, one that stares out at the

David Garner, 'Pockets of Resistance' (2004) 255x248cm
Tarpaulin pockets covered in pockets from everyday garments

world with worried eyes, slightly aghast. That in itself perhaps says a lot about Wales.

There is still no critical magazine for visual arts in Wales. Although interesting critical arguments feature in essentially literary publications (*New Welsh Review*, *Planet*, *Barn* and *Taliesin*), these cannot sustain lengthy argument, sufficient illustrative material, or appropriate advertising, without distorting their prime commitment. As an example: although postcolonial critique as a method of analysis for cultural production in Wales was recently the subject of furious debate in The *New Welsh Review*, few visual artists access these publications and are hence not party to such discourses and their relation to Wales. It was once mooted that visual arts might be included in the architecture magazine *Touchstone*, but whilst this might seem pragmatic, it would be completely detrimental to the art, as almost always happens when these two disciplines come together. It is always assumed that they are similar practices, which can be co-opted to work together easily. This, is seldom the case, and close integration of art in architecture with a few exceptions, is detrimental to the art, and results, as I have said before, in something less than art.

The new buzz-topic in our 'nation-building exercise' is 'architecture and the built environment', yet so much of what is good in aesthetic intention is scuppered by visionless planning departments and the dreary justification of mediocrity in order to satisfy supposed 'market demands'. Consider that mess of missed opportunity which is Cardiff Bay: Lloyd George Avenue, the gateway to the new National Assembly, is a featureless wind-swept drag (and we were promised Las Ramblas!). That this has happened in a city containing the civic brilliance of Cathays Park is doubly ironic. But built fabric is one thing; ideas something else and it is ideas which ultimately create a robust culture. Ideas cannot just be imported, they need synthesis: artists, writers, those makers of 'expressive culture', need to be

engaged with the history and the events of this place in all its particularities and peculiarities. And, might not an appropriate metaphor for this be a comparison between the (embarrassing and provincial) 'look at us, we can do the West End' spectacle, which was the opening ceremony of the Wales Millennium Centre and that of Galeri in Caernarfon, which was an assertion of exceptional 'home-grown' talent of substance and was therefore not provincial at all.

'Take me somewhere good' suggests that as a culture we are too often fixated on asking someone else, someone elusively 'in the know', to guide us. Artists in Wales are asking this less and less, as they participate in a lively artworld right here in Wales. This publication goes some way to reveal that. It is a record to show what is going on, but it is also a signpost, one pointing us forward. 'Somewhere good' is always on the horizon.

Notes

1 In *Song from a Forgotten City* Ed Thomas, Parthian Books 2002.

2 Donald Kuspit, *The End of Art*, Cambridge University Press, 2005.

3 Suzi Gablik. 'The New Front' *Resurgence* No. 223 March/April 2004

4 Quoted by Ruth Shade (referring to theatre performance practice in the south Wales Valleys). See: Ruth Shade. *Communication Breakdowns,* University of Wales Press, Cardiff, 2004.

News, views & reviews

Eija-Liisa Ahtila from 'The House Of Prayer' (2005)

To quote Osi Rhys Osmond, the bookshelf for Welsh Art still needs lengthening, but more historical and critical material is becoming available for students and lay enthusiasts alike.

COLOUR AND LIGHT
Fifty Impressionist and Post-Impressionist Works at the National Museum of Wales

Ann Sumner (£16.99 pb NMGW, 2005)

The famous collection of Impressionist paintings at the National Museum of Wales is analysed and celebrated in this well-produced book. Short preparatory essays tell us something of the Davies sisters, of the nature of Impressionism and of collecting in the nineteenth and early twentieth centuries. The body of the book consists of reproductions of fifty paintings, with short commentaries on each written by the named author with further contributions by Louisa Briggs and Julia Carver. The artists represented range from the very famous – Cézanne, Degas, Monet, Renoir, Rodin, Whistler, to the merely famous – Berthe Morisot, Henri Fantin-Latour, Othon Friesz. Each painting is illustrated in colour and accompanied by captions that include, together with the usual dates and dimensions, details of its acquisition by the museum. The commentaries are clear and informative, although they tend to concentrate on the biographical and the historical, rather than to be critical and analytical. This makes it an ideal book for someone coming to the whole field for the first time, or for anyone who wants to re-acquaint themselves with a particular work.

Derrick Price

IMAGING THE IMAGINATION
an exploration of the relationship between the image and the word in the art of Wales

Edited by Christine Kinsey and Ceridwen Lloyd-Morgan (£24.99 hb Gomer, 2005)

Several of the contributors to this book are anxious to challenge (yet again) the canard that there is no developed tradition of the visual arts in Wales. But they also argue that the literary and the visual interact here in particular ways and with exceptional resonance. This, then, is a book about the visual arts, writing and the creative imagination within the context of Welsh culture. Osi Rhys Osmond spells out its primary intention in clear terms:

> The purpose of this book is to demonstrate and illustrate the historic and contemporary relationship between the word, particularly poetry, and the image, particularly painting, in the culture of Wales.

At the core of the book is a series of essays on significant artists, each of which explores his or her relationship to the word. All of these pieces are interesting, although some work better than others in exemplifying the connections between writing and painting. I found the most complex and satisfying to be those where the artist had directly addressed the nature of this relationship. For example, Anne Price-Owen unpicks the association between words and images in David Jones' work in a most elegant way, and Jill Piercy makes

clear the tension that working in more than one art form had on Brenda Chamberlain's life and practice. On the other hand, Ceridwen Lloyd-Morgan's essay on Gwen John is stimulating, but seemed to me to be less illustrative of the main theme. Very different kinds of artists are considered here: Peter Wakelin writes on Ceri Richards, Ernest Zobole's relationship to words is considered by Ceri Thomas, while Osi Rhys Osmond examines the plural ways in which word and image are important to contemporary artists such as Iwan Bala, Ivor Davies, Sue Williams, Christine Kinsey and Shani Rhys James. These essays are contextualised by a piece from Ceridwen Lloyd-Morgan that briefly explores the relationship between image and word in Wales since the fourteenth century.

If the first aim of *Imaging the Imagination* is to illustrate the relationship between words and images, a second – more problematic one – is to develop, from the diverse case studies, a central thesis: that the visual arts of Wales are, to an exceptional degree, intertwined with the literary. There are some difficulties standing in the way of this project. 'Words' are encountered in very different kinds of personal and public writing – in poems, letters, novels, or criticism. By the same token, 'images' are influenced by words in diverse ways. In some cases, for example, poems are said to inspire paintings in a rather general way, while in others, words are directly incorporated into paintings to point up cultural, political or spiritual ideas. The multifarious ways in which the literary co-exists with the visual, and the easy elision between the two, inevitably leads to some conceptual confusion. Metaphors of the creative process begin to stand in for critical language: a visual imagination manifests itself in writing; a painterly eye informs a poem, a literary sensibility lies at the heart of a painting. Another problem is that the principal agency through which we are invited to view these acts of elision between art forms is that of the 'imagination'.

But this is another rather slippery word. 'Imagination' is an attribute of human beings; one that can be viewed as if it transcends circumstances and material determinations. It may tell us something about the feelings and responses of an individual artist, but it is not a very precise concept in cultural analysis.

Nevertheless, the book raises interesting questions about the nature of Welsh culture (itself treated as an unproblematic concept) in relation to both the visual and the literary. The history of art in Western societies in the twentieth century has been told as a series of radical ruptures, breaks and dislocations with the past. What is fascinating about this work is the way in which it concentrates on teasing out agreement and continuity, not only from one generation to another, but between art forms. A particular kind of cultural sensibility is being evoked through the putative special relationship of word and image – one that imagines artists as possessing and responding to familiar and agreed objects of concern. This is one way of understanding, describing and celebrating the culture and the authors of this serious, well-written book have made their case well. They call for further debate and it seems clear that other accounts of the relationship between word and image will emerge.

Derrick Price

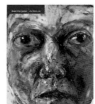

SHANI RHYS JAMES: THE BLACK COT

Edited by Eve Ropek (£19.99 pb Gomer, 2004)

Adhering more to the conventions of an exhibition catalogue than a book, this publication was produced to coincide with a major exhibition at Aberystwyth Arts Centre. Most of the text is by the prolific and ubiquitous Ted Lucie Smith who, in his opening sentence, refers to the Jerwood Prize for Painting (which Rhys James won – to a satisfying gasp of horror from the

London art establishment – in 2003) as "currently Britain's most valuable art prize". This might cause one to question any assertion following but as usual he writes lucidly on the artist, establishing her firmly in the context of European and British painting. Artists as diverse as Artemisa Gentileschi and Frida Kahlo are invoked but there is not much reference to the Welsh context, apart from cursory mentions of her winning the Mostyn Open and getting something at an eisteddfod. No mention either of any other Welsh artist, or to the strong tradition of painting in Wales. Otherwise the book is a handsome job and one with which any artist might be pleased. Spacious, well-illustrated and nicely designed (it is refreshing to see a spread of drawings, which alleviate the otherwise pervading angst somewhat), it does though lack a bibliography, which would have been useful, if only for less orthodox Boswells.

Rogelio Vallejo

STILLED (Contemporary Still Life Photography by Women)
Edited by Christine Rolph and Kate Newton, (£19.95 pb Ffotogallery, 2006)

This is a characteristically elegant publication from Ffotogallery; the design cool and immaculate and the illustrations are, as they should be, well chosen and perfect. The accompanying text is clear and authoritative. This volume is the third in a series of publications considering the situation of women's photography under the traditional categorisations applied to painting. It is thus a fitting sequel to the equally excellent *Masquerade*, which looked at women's contemporary portrait photography, published in 2003 and *Shifting Horizons – Women's Landscape Photography*, of 2001.

In their introduction, the editors claim a particular affinity between women photographers and the still life genre based on the not unsurprising linkage of the former with confinement in general and domesticity in particular. This parallels the traditional strong identification of women with folk art and certain home crafts. This however is to deny the sheer sophistication and catholicity of the works, which stray far from the domestic and onto the further shores of the unexpected. The whole series is of seminal importance in the study of photography and unusual in that the sometimes harrowing language of photographic theorising is here leavened with images of considerable sensuality and not a little joy.

Rogelio Vallejo

THE PAINTER'S QUARRY: The Art of Peter Prendergast
David Alston et al (£25.00 hb Seren, 2006)

This collection of essays is a moving introduction to the art of one of the most acclaimed painters working in Wales today. It was published to coincide with a major retrospective exhibition of his work (Oriel Ynys Môn, Llangefni, and touring). As such, it is a welcome addition to the growing body of writing on the art of Wales today, much of it published, as here, by Seren. The title, shared by the exhibition, is something of a play on words, a reference of course to the subject matter of the Bethesda quarry paintings that made his name in the 1980s, but also to Prendergast's personal quest to convey the emotional essence of landscape.

With the exception of John Russell Taylor's introduction which contextualises Prendergast's hard-wrought and still-evolving expressionism, each essay discusses a phase of the artist's career. Many of these go beyond the biographical. Peter Wakelin describes Prendergast's education as an artist, at Cwm Aber School, and at Cardiff College of Art in the early '60s, but places this within the broader south Wales art scene of the period, a subject that demands a book of its own. Peter

Davies takes him from Cardiff to the Slade, and Reading University. Robert Macdonald covers the move to Bethesda. Lynda Morris writes of Prendergast today in Deiniolen and Tony Curtis of the paintings of the last twenty years. David Alston's conclusion explores his recent seascapes.

So the book tells us much we need to know. Does it capture the essence of Prendergast's work? Not entirely. Some of its physical character is inevitably lost on the printed page – the way the drawings are made up of overlaid sheets of paper, the impasto bubbling over the roughly joined boards of the oils, the sense of rapidity and vigour in the acrylics. His luminous greens and yellows are difficult to reproduce, but the book is let down by a few shoddy illustrations. Sadly the early 'Self-Portrait in Green' is muddy and unreadable. So buy it – but see the exhibition too.

Oliver Fairclough

Other recent publications include *Sideways Glances*, edited by Jeni Williams. This is a series of essays on 'five off centre artists in Wales', those held to have 'culturally marginal' practices: Neale Howells and Eddie Ladd are the visual artists. Where the 'centre' might be in this case is a moot point but it is evidence of a growing awareness of the multi-faceted nature of Welsh art and the blurring between traditional artistic categories. It is the first of a promised series of art books from Parthian.

Gomer monograph on painter Mary Lloyd Jones was launched in 2006. We also look forward to Ceri Thomas' work on Ernest Zobole, which Seren is to publish.

NMGW published *An Art Accustomed Eye, John Gibbs and art appreciation in Wales 1945-1996* by Peter Wakelin; *Venice Agendas IV: Neighbourhood in Dialogue*, edited by Bill Furlong and published by a consortium of British art schools, including Newport and Cardiff. This is an account of traditional, if not tedious, discussions of the significance of the biennale for art and artists (from audioarts@aol.com). The catalogue of the Welsh exhibit at Venice *Somewhere Else*, is obtainable from the Wales at Venice office (www.wales@venicebiennale.org).

Simon Fenoulhet: Another Light is a handsome catalogue, in English and Welsh versions, with a critical essay by Anthony Shapland, published to coincide with last winter's exhibition at the Glynn Vivian Art Gallery.

Richard Cox Unfinished Business 75 30 05, with an essay by Anne Price-Owen, is the latest in a series of important publications by Newport Museum and Art Gallery initiated by the excellent Sandra Jackaman (whose quiet, yet significant, contribution to Welsh art is hugely under-appreciated).

The Institution, published by Chapter, is a photographic record by Phil Babot of André Stitt's solo show there in 2005.

Groundbreaking: the artist in the changing landscape, edited by Iwan Bala and published by Seren in collaboration with Cywaith Cymru, includes a number of seminal essays and celebrates twenty five years of activity in the field of commissioning artists to work on public art projects and residencies in Wales. Another publication, which will also be of interest to all those concerned in debating public art, is a similar celebration of an art agency: Oxford-based Artpoint celebrated its tenth anniversary with *Reviews: Artists and Public Space*, edited by Ruth Charity (Black Dog Publishing, 2005).

OBITUARIES

Peter Bailey (1944-2005)

Peter Bailey was a collector of sorts – a gleaner gathering objects from his environs – from the streets, from charity shops, jumble and car boot sales, beaches, fields and pathways. Bailey continually scoured, inviting pieces of apparently mundane detritus – shards of porcelain, key rings, crushed birdcages, costume jewellery, toy animals, dolls, bricks, shells and old shoe leather – to engage his imagination.

As a child in Cefn Mawr he brought home objects of fascination – vitrified cinders with their rainbow strata, fragments of steel – elements of an industrial past. He hid many treasures and used others in play, alongside more conventional toys, whereupon the young artist assigned them a fresh meaning.

Though he used everyday objects 'found' in his everyday life, Bailey's collecting was not simply archaeological. Some things were stored for years in the studio, or at home, in ordered boxes containing families of objects, until the artist selects them as the right character – visual and literal – for the story he was currently telling. Although somewhat archaeological in his approach Bailey was able to affect their meaning and the way in which they might come to represent the communities from whence they came. The objects were the means through which Bailey viewed the world and the tools of his poetic response to it. He was attracted to objects, not for their immediate symbolism, but for their capacity for transformation, so that they became part of the vocabulary of his own language. His relationship with them was one of a poet to words, their meaning and juxtaposition.

Bailey's narratives are allegorical. The objects are his language and their arrangement carries the core message through metaphor, layered and entwined in sculptural pun, complex tableaux, or assemblage. He had, he said, no choice but to work in this way and explained his relationship with the world as one filtered through its fragments. His openness to the possible, his child-like wonder – as with a glass marble in which a universe might be imagined – remained constant in a body of work that counters wry and occasionally bawdy, humour, with an incisive and insightful view of the world.

Carole-Anne Davies

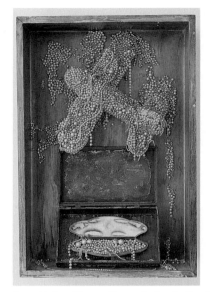

Peter Bailey 'Nature Morte, Fruits de Mer II'

Gordon House (1932-2004)

The name Gordon House will be well known to anyone familiar with the British art scene of the sixties and seventies. Not only was House an accomplished artist and designer (he worked for the Beatles, designing their 'White' album and with Peter Blake on the 'Sergeant Pepper' cover) but his aesthetic profoundly affected catalogue and exhibition gallery design: typically, he not only showed work in the influential SITUATION exhibition (1960) but also designed its catalogue. He continued painting throughout his life and his prints and paintings, particularly during his last years, during which time he spent considerable

periods in Wales, referred to the Swansea Valley and Pontardawe, where he was born. Bernard Cohen, in a *Guardian* obituary, wrote "...he used his brush to walk a path through memories of collieries, valleys, smoking stacks, rows of cottages and the people who nurtured him.... I can only imagine that his later paintings were made in homage to the human and environmental struggles of the country of his birth".

Hugh Adams

Jonah Jones (1919-2004)

Jonah Jones was an indefatigable maker across several media and art forms; he was a great supporter of the arts and artists, especially in his adopted country of Wales. His paintings, prints and three-dimensional works are in most of our public collections, including the memorial plaques for both Dylan Thomas and Lloyd George in Westminster Abbey and the mural for Tenby Museum and also in many private homes across the UK.

His artistic training was unconventional – three years up to the war, studying part-time at King Edward School of Art in Newcastle; he then followed John Petts into the Parachute Field Ambulance unit, simply and remarkably, in order to meet an artist whose work he'd seen and admired. Jonah would not bear arms and he served as a pacifist unarmed medic. Together with Petts he'd run an occasional printing press in their unit. He saw active service, being dropped into occupied Europe and later passing through Belsen and going to Palestine. After de-mob, he returned to Gwynedd and the Caseg Press, but then had a period, in 1949, at the Eric Gill workshops in Pigotts, Buckinghamshire, where he learned to carve in wood and stone. He worked with Laurence Cribb, one of Gill's closest friends and occupied the room that David Jones had had in his time in that Dominican lay community.

Jonah's public service included four years as Director of the College of Art and Design in Dublin and the Kilkenny Design Workshops (1974-8) and he also served on the Art Committee of the Welsh Arts Council. He was Gregynog Arts Fellow in 1981/2 and in 1983 he was awarded the Queen's Jubilee Medal for services in the Arts.

He sculpted heads of Bertrand Russell and John Cowper Powys, amongst others. In his later years he suffered from arthritis and concentrated more on watercolours and calligraphy. Jonah was also an accomplished writer: works include an autobiographical essay in Meic Stephens' *Artists in Wales* (1971), and two novels, *A Tree May Fall* (Bodley Head, 1980) and *Zorn* (Heinemann & Penguin 1986 & 1987). Seren published his book of essays and remembrances *The Gallipoli Diary* and his memoir *Clough Williams Ellis*.

Tony Curtis

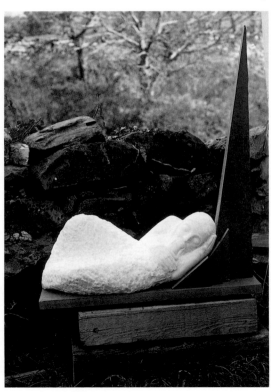

Jonah Jones, 'Jacob at Peniel' (1979) marble and slate

Geoffrey Jones (1931-2005)

> He stands alone within this genre of film-making as a singular artistic voice... His films are unique and you can't help but be impressed by his use of editing, his shooting – he's got an incredible eye – and the way he matches music to image...[1]

The name of film-maker Geoffrey Jones would be far better known had he not worked in the unglamorous world of the industrial documentary. But the short films he made for Shell and British Transport in the 1950s and 1960s, and now released on DVD[2], are winning a new generation of admirers. Out of subject matter as tedious as oil pipelines and train services, Jones conjured witty, visually arresting films, dazzlingly edited to music. Geoffrey Jones was born to Welsh parents in London in 1931 and came under the spell of cinema while at art college. His finest film was *Snow*, nominated for Best Short Film Oscar in 1965. Shot entirely from a train window, the film is a breathtaking portrait of Britain in the grip of the freezing winter of 1963/4. Jones made visual poetry from the blurred winter landscapes through a blizzard of single frame edits and surreal frozen scenes. It came as no surprise to find out that Jones' friend and mentor was the great Brazilian surrealist Alberto Cavalcanti. After the collapse of industrial film-making in the 1980s, Geoffrey Jones retired to a cottage near Llandovery. But his zest for cinema remained undimmed and even in his last years, helped through an Arts Council for Wales grant, he created two short films playing with the possibilities of the latest video editing.

Steve Freer

1. James White, quoted in Stephen Moss, 'The Last Picture Show' (*The Guardian* 24.6.05)
2. Ironically the CD *The Rhythm of Film*, which contains nine short films by Geoffrey Jones, was released by the BFI less than a week after his death.

NEWS

The new Mostyn Art Gallery

The presentation of proposals for the new Oriel Mostyn gallery by Ellis Williams Architects is a timely moment to reconsider the programming at the gallery and initiate a strategy, in both the long and short term, for the new and existing spaces. The space available for exhibitions will be enlarged by approximately 50 percent across a total of five galleries. Four of these will be linked to each other on the ground floor and will include the two existing galleries, to be refurbished without any loss of their architectural detail. The other two will be new and comprehensively climate controlled. The fifth gallery, also new, will be on the first floor.

Flexibility will be a key requirement of any new programme, allowing for a number of possible scenarios. These, such as they exist at the time of writing, are not immutable, rather they serve to open a discussion. The need to display art sensitively and under the best possible conditions remains paramount, and has informed all aspects of the project so far. In the course of the past five months many issues have arisen, each in their turn, for consideration, with considerable implications for any future programme of exhibitions. All have been wrestled with. Oriel Mostyn is particularly fortunate, at this juncture, to have plans on the table for five unique galleries, and recent confirmation of a Lottery grant of £2.6 million.

Anders Pleass
Exhibitions Officer, Oriel Mostyn

Artshare Wales

is the National Museum's visual arts partnership scheme, which covers five venues "selected for their geographical spread and cultural diversity" (in the Arts Minister's words) and "will constitute a national gallery without walls". This might seem

to bode ill for those of us who are hoping for a few more walls (a National Gallery of Welsh Art or a serious national gallery for large-scale touring exhibitions, for instance...) Ruthin Craft Centre, Oriel Mostyn in Llandudno, Oriel Davies in Newtown, the Glynn Vivian Art Gallery in Swansea and Bodelwyddan Castle near St Asaph's will benefit from circulating loans from the national collections. The cost of the Visual Arts Partnership is £185,000 (£30,000 from NMGW; £5,000 from the Arts Council of Wales; £30,000, the partner venues and £120,000 from the Esmée Fairbairn Foundation, which is increasingly responding to cultural funding opportunities in Wales).

The AXA Art Photographic Portrait Commission 2005

Sponsored by AXA Art Insurance Limited, the Commission selects sitters with a connection to Wales who have excelled in their particular field. It is open to photography graduates who have graduated in the last five years and who are looking to establish themselves professionally. In 2005 the judges selected Dominic Hawgood and Ric Bower, whose respective portraits of Dr Rowan Williams, Archbishop of Canterbury and the novelist Sarah Waters enter the National Museum's collection.

Dominic Hawgood grew up in Shropshire and graduated in 2005 from University of Wales, Newport with first class honours in Photographic Art. During his studies he exhibited in group shows, and in April 2005 was a finalist in the first annual Bright Young Things exhibition in Berlin. Hawgood says of the project: "This commission, my first, is a signifier of my drive to inject my practice with a new professional relevance, and to apply my skills in new ways".

Ric Bower was born in London and now lives and works in west Wales. He studied Fine Art in Manchester, and in 2005 gained a first class honours degree in Photography from Coleg Sir Gar, Carmarthenshire. Previous exhibitions include a solo show in 2001 at the Emrys Gallery in Haverfordwest. An established portrait painter, he has recently changed to photography, and achieved third place in the Schweppes 2005 Photographic Portrait Prize.

Ric Bower
'Sarah Waters'

Sam Dargan 'Impromptu Resignation Speech' (2005)
Oil on board 29 x 42 cm. Courtesy the artist and Rokeby Gallery

The 16th Mostyn Open

Held annually, with a prize of £6,000, this is one of the UK's most important open exhibitions for young and emerging artists. The winner in 2006 was Sam Dargan, whose work is "largely about frustration and alienation in contemporary life". He graduated recently from The RCA and has exhibited in group shows at 131 Brick Lane and the NCA, Sunderland. He is represented by the Rokeby Gallery, London.

The Richard and Rosemary Wakelin Purchase Award 2006

This award is given annually to an artist or craftsperson and takes the form of a purchase for the permanent collection of the Glynn Vivian Art Gallery by its Friends. This year's selected artist, Dick Chappel, lives and works between Brynmawr and Abergavenny. His painting 'At Night' was completed in 2004, during a protracted period of work on the Gower peninsula.

Beck's futures

Bedwyr Williams was shortlisted for the 2006 prize, which was won by Matt Stokes.

The Sir Leslie Joseph Young Artist Award

This competition takes place in alternate years and in 2005 was awarded to Richard Monaghan, who lives and works in Swansea. It represents an opportunity for artists to have their first exhibitions in a public gallery. The prize is funded by the Friends of the Glynn Vivian Art Gallery, as a result of a gift made by the late Sir Leslie Joseph. A prerequisite for entry is that the artist must have been at least partially educated in Wales. Previous winners have been Will Nash, Thomas Lewis, Daniel Molloy and James Donovan.

University of Glamorgan Purchase Prize

This £3,000 purchase prize was awarded to Ken Elias and selected by Brendan Burns from an exhibition shown at the Wales Millennium Centre. Burns wrote "...I have tried to avoid 'personal taste', and tried to curate an exhibition which can stand independent of the competition". Elias' work joins that of Jack Crabtree, David Garner, Ivor Davies, David Nash, Iwan Bala, Ceri Richards and Ernest Zobole, among others, in a comprehensive collection of Welsh art, one recently accorded museum status.

Creative Wales Awards 2005

Visual artists and craftspeople fared extremely well carrying off the major proportion of awards. Lois Williams (£25,000); Richard Higlett (£8,250); Shani Rhys James (£10,000); Jennie Savage (£9,950); Richard Huw Morgan (£20,000): Emrys Williams (£10,000), Bedwyr Williams (£10.000).The awards are unique in celebrating the creativity of artists living in Wales and "represent a significant investment by the Arts Council of Wales in individual artists". Grants of up to £25,000 were awarded to established artists from a variety of different disciplines including visual arts, ceramics, photography, literature and music. The stated aim of these awards is

to develop excellence and to build sustainability in the arts by supporting artists in creating new, experimental and innovative work that takes forward their art-form and artistic practice. It provides artists with the opportunity to concentrate on developing their work in time intensive and exploratory ways, temporarily free from their usual commitments.

KIM FIELDING is a fine art photographer but can best be described as a multi-media artist, as his work often involves performance but is always photographically based. He has lectured part-time at UWIC and Swansea Institute. He is a founder member of tactileBOSCH, and exhibits his work locally and internationally. He intends to use his award to push

> the boundaries of photo-visual practice through placement of the work, method of installation and 'framing'.

His intention is also to stretch the boundaries of medium, moral judgement and geography.

RICHARD HUW MORGAN describes himself as an 'interdisciplinary experimental artist working in live and mediated media'. Currently a part-time lecturer in time-based practice at Cardiff School of Art, he has had a varied career, having a MSc (Econ) Media Studies from the Centre of Journalism Studies, University College Cardiff and a BSc (Econ) Philosophy from the University College Swansea. A core member of experimental theatre company Brith Gof, he has undertaken work as a freelance artist/designer with Carlson Dance Company, Ankst/Anskstmusik and Chapter Arts Centre and is also currently the Co-artistic Director/Administrator of Good Cop Bad Cop, Cardiff. His project is an audio research one, to generate field recordings of contemporary Wales using a broad range of sources – cultural, social and environmental – from across Wales. These will be recorded to provide the raw materials for an audio archive that can be isolated, manipulated and combined for re-presentations including sonic

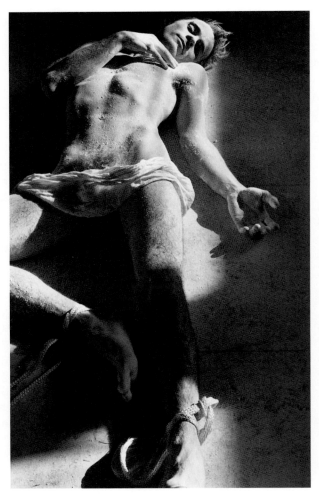

'Hanged Man' photograph by Kim Fielding

installation and vinyl records.

EMRYS WILLIAMS is a painter, based in Cardiff. In his work he creates "a personal world of memory and recollection; boats, clouds, figures with umbrellas etc, become elements in a fragmented narrative". He has work in numerous collections including the Metropolitan Museum of Art, New York; the Government Art Collection, London; the National Museum, Cardiff; Arthur Anderson and Co and the Glynn Vivian Museum

and Art Gallery, Swansea. His award allows him to

further explore ideas that have been generated in earlier short residencies in Wales and Ireland. In both cases there is potential for longer-term development of the formal changes that are evident in my recent studio work.

50 over 50 (the 'Celebrating Age' Open Art Prize)

Artists from across the UK took up the challenge of the first national open art exhibition for artists over 50. '50 over 50: the Celebrating Age Open Art Prize' was launched in February in association with the University of Brighton and Brighton and Hove Arts Commission, to celebrate the best contemporary visual art by older British artists. Over 1,800 entries were received, representing art forms including painting, sculpture, printmaking, timebased media, installation art and digital art. After much deliberation, judges selected 50 exceptional art works, made since January 2004, for display at the University's gallery during August 2006. The overall winner was presented with a cheque for £5,000 by Sir Christopher Frayling, Chairman of Arts Council England at the opening party in July.

The judges were: Caroline Collier, Head of National Initiatives at the Tate; Raimi Gbadamosi, internationally acclaimed artist and curator; Roger Malbert, Senior Curator at the Hayward Gallery; Norbert Lynton, acclaimed academic and author; and Cyril Mount, a practising artist for over 50 years, whose paintings of political and social commentary are exhibited internationally.

50 over 50 has pioneered electronic submission of entries via www.50over50.org.uk and CD, proving by the sheer number of entries received, that older people are no strangers to change and new technology. 50 over 50 was a professionally curated exhibition of new and recent works by some of the most talented and experienced artists in the UK. This landmark show emphasises excellence and innovation in the practice of older artists as it reveals and celebrates the contribution older people make to contemporary culture.

Oriel Canfas Gallery

Oriel Canfas Gallery is the flagship of Old Library Artists Ltd. OLA is an artists' co-operative formed in 1995 while the artists were housed in the Old Library, Cardiff. Since opening it has exhibited over 200 artists in mixed and solo exhibitions. Housed in the residential area of Canton in a converted canvas/tentmakers warehouse it now provides a small welcoming exhibition area and education space as well as studios for the co-op members. The gallery exhibits contemporary art from all disciplines of current visual arts practice including painting, sculpture, photography, printmaking, video, installation and others.

Cultural movers

The University of Glamorgan has announced plans for an arts and cultural industries campus in central Cardiff and confirmed the go-ahead of an exciting £35m development plan. The campus will be situated in a totally redesigned and refurbished building in the city centre and will house the new Cardiff School of Creative and Cultural Industries. This new faculty is planned to open in 2007.

A new multimillion pound campus for Newport's city centre has been given the go-ahead by the University of Wales, Newport, Newport City Council and Newport Unlimited. The £20m campus will be situated on the banks of the River Usk in the city centre, and will be the first phase of an intended £50m development for the University. Initially it will house the Newport School of Art, Media and Design, signalling a return of the School to the centre of the city. The first phase will be developed by the University of Wales, Newport, with partnership funding from Newport City Council and Newport Unlimited. Designs for the new campus have been commissioned, and it is

anticipated that building will start in early 2007, with students using it by the autumn of 2009. The new campus will be part of a lively cultural hub on the banks of the Usk, and attract other facilities and amenities, including the possibility of an international art gallery.

What's Welsh for Performance? (Beth yw 'Performance' yn Gymraeg?)

This is a five-year research project (2006-2010) led by Dr Heike Roms of Aberystwyth University devoted to uncovering and archiving the history of Performance Art and forty years of 'Action Art' in Wales. She writes: "The history of performance art in Wales has yet to be written. Over a period of nearly forty years artists have been creating performance, action or time-based art in this country, yet their work remains largely confined to oral history, to half-remembered anecdotes, rumours and hearsay. As early as 1968, Welsh artist Ivor Davies, protagonist with Gustav Metzger of the 'Destruction in Art' movement, staged happenings at Swansea University. The National Eisteddfod of 1977 in Wrexham became notorious for its international performance programme featuring Joseph Beuys, Jannis Kounellis, Mario Merz and impromptu interventions by Welsh artist Paul Davies. In the 1990s, Cardiff Art in Time provided an important platform for international and local performance work... One often searches in vain for traces of these events in the official annals of Welsh art history. Surprisingly for an artistic genre so committed to documentation and theoretical reflection, there are no publicly accessible archives dedicated to performance art in Wales, no books, no journals. And yet, the contemporary performance art scene is still one of the most vibrant anywhere in the UK.

The distinctiveness of performance art in Wales derives from a fusion of global artistic developments with local cultural and political desires. The earliest art actions that appeared in this country in the late 1960s and early 1970s were inspired in equal measure by the movement of the international avant-garde toward a dematerialisation of art practice and by the local reaffirmation of a distinct cultural identity that manifests itself primarily as performance (above all as the celebration of the Welsh language). This was accompanied by a political activism that also gathered pace in the sixties through harnessing performance's radical potential for direct political action in the struggle for the survival of the language. Wales has often been called 'England's first colony' – a marginalised culture turned to a marginal art practice as a means for its cultural and political expression. As a consequence the division between different artistic disciplines has been of lesser importance than the question of where these disciplines situate themselves in the cultural and political landscape of Wales. In its quest to develop a distinctive form that could provide an alternative to the dominant English mainstream for example, Welsh experimental theatre from its earliest manifestations embraced artistic strategies that we have come to know from

Ivor Davies 'Adam on St Agnes Eve' performance UCW Swansea, 21 January 1968

performance art, such as site-specificity, duration and active audience involvement. As a result, the term 'performance' in Wales today describes a fluid field of innovative practices originating in a variety of disciplines, including performance art, sonic art, experimental theatre, movement work, and performance poetry."

What's Welsh for Performance? intends to create: a searchable on-line archive as a 'virtual' index that allows users to locate where documentary material on performance art in Wales is currently held (this will be online from January 2007); a series of publicly staged interviews with artists, administrators and audiences, devoted to key artists, institutions and events that have influenced the performance art scene over the past 40 years (from October 2006); The Stall/ Y Stondin (working title): a mobile temporary installation devoted to an oral history of performance (to be installed at key events during 2006-2008); The Lecture/Y Darlith (working title), a series of public lectures be offered to universities, further education colleges, schools and art societies around Wales (throughout 2008); a documentary publication including a chronology, critical essays on key artists, institutions and networks, themes and movements, and a bibliography of relevant publications; accompanied by a DVD (publication planned for 2010).

The British Art Show

As usual, appears to be something of a misnomer and maybe the Very Southern English Art Show would be a better title and expressive of the prejudices prevailing. It didn't come to Wales (nor Scotland or Northern Ireland and the nearest venues to Wales were in Bristol) and there's little in it to interest anyone hoping to see Welsh art or artists. In fact there is no instance of a Wales-practising artist, though two are Welsh by birth. What message are we supposed to take from this? A number of curators and cultural bureaucrats in Wales are acknowledged in the catalogue credits list but one would like to know whom they might have suggested for inclusion and how many artists were actually contacted and studio visits made. One of the selectors, Alex Farquharson, was employed, albeit briefly, at the CVA and the other Andrea Schleiker, spent some years at Arnolfini but maybe this didn't equip them sufficiently to realise that there are some quite good artists this side of the Severn? Are they really suggesting that there are not even half a dozen artists in Wales to fit in with their (rather loosely pragmatic) 'multicultural' hypothesis and worthy of inclusion? Are the organisers asked to account for the lack of a non-English venue and the absence of a single plausibly Welsh artist? Some British Art Show!

Hugh Adams

Leaving, Arriving, Animating and Flourishing: Just what has g39 has been up to?

Ever energetic and increasingly internationally active, g39 has been involved in a number of initiatives on the 'elsewhere' front: FLOURISH, at The Moravian Gallery, Brno in the Czech Republic, was co-curated by Marek Pokorny and Anthony Shapland of g39 and featured the work of thirteen artists from Wales:

> In a show such as this where one geographical common thread already exists we hesitate to add others. A small nation like Wales, under threat from greater powers, has a tendency to play it safe. The suspicion of the New is ever-present but the tension that exists between the pull back of tradition and the pull forward of the future is an essential factor for its contemporary artists. Often from the margins you can just look towards the centre but it is from here, on the periphery that you get a clearer view. This is also true of logic. The further you are from the anchor of established fact, the closer you come to the mire of possibilities.
> (Anthony Shapland)

Among artists represented were David Cushway, Eve Dent, Sara Rees, Cerith Wyn Evans, Craig Wood, Meriel Herbert, Gordon Dalton, Neal Rock, Bedwyr Williams, Angharad Pierce Jones, Michael Cousin, Richard Higlett and Tim Davies.

FLOURISH challenged the idea that art is an unnecessary gesture made to a world that believes it could continue without it. Visual art has sometimes been perceived as frivolous when pitted against unemployment, or a lack of hospital beds, as though the two are in direct competition. But it is these stands against the accepted order of things and often against logic, that vocalise some of the most potent, most interesting and necessary ideas of progress.

ON LEAVING AND ARRIVING took place in late Summer 2005, and was 'housed' in a series of shipping containers placed around Cardiff and at g39. These held contemporary works by artists selected both from the UK and a handful of the many port cities that are, or were, linked with Cardiff by commercial sea routes. It profiled nine artists looking at notions of displacement, of leaving and arriving, of crossing a threshold into another place. The exhibition was one of a series of international projects g39 organised to bring international contemporary artists to Wales and increase the recognition of contemporary artists from Wales worldwide.

This project continued a season which had focussed on ideas of migration and integration, and Wales' relationship with the world. Also shown at g39 in September 2004 were THE INDEPENDENTS – which featured six artists from

Bedwyr Williams 'Dinghy King'

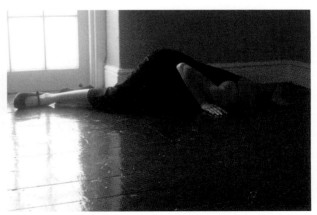

Eve Dent 'Beneath the Surface'

Croatia and 'Anima' (July 2005), was an exchange project with B-312 of Montréal; it featured twelve artists from Wales and Québec.

g39 is still putting the money together for a series of residencies in Italian cafés throughout the valleys, in a study and celebration of the influx of Italians during the industrial revolution in south Wales. This promises to be an extremely interesting project, so it is difficult to understand why grant aid and support is so slow in coming, particularly from local authorities. Certainly the ambitious project would seem to hit all the right 'accessibility' and 'cultural diversity' buttons ACW keeps harping on about. But, to paraphrase Railtrack, maybe its the wrong kind of accessibility and the wrong sort of diversity?

Hugh Adams

Young Curators Group

This is a novel scheme, operated at Oriel Davies, Newtown, in order to introduce people aged between fifteen and twenty five to exhibition curation. There is no necessity for either studying art or being in education to join. Its programme involves visits to other galleries and exhibitions as well as the whole gamut of activity associated with mounting an exhibition from the generation of the original idea to post-event evaluation and feedback. Details from the gallery: 01686 625041.

SHIFTwork

This is a time-based art research group whose core members are André Stitt, Paul Granjon, Simon Aeppli, Dr John McNorton and Phil Babot. Based at Cardiff School of Art & Design, associate members include Eddie Ladd (Performance & new technologies, Wales), Dr Heike Roms (Performance Studies, University of Wales, Aberystwyth) and a number of overseas artists and institutions, including: Draw International, Caylus, France; Le Lieu, Centre en ArtActuel, Québec; InterFace, University of Ulster; Franklin Furnace Archive, New York. Future initia-

tives include a resuscitation of Cardiff Art in Time in 2007, a week-long festival of performance art produced in collaboration with TRACE, Cardiff School of Art & Design, Chapter and the National Museum of Wales.

The programme will include work by international artists, lectures, exhibitions, installations and a student programme of work from selected art schools in the UK.

Star Radio

This 'process-based' artwork, was the initiative of Cardiff artist Jennie Savage. Its aim was to explore notions of time and place within the context of a specific urban location, doing so through the medium of local radio broadcasting. The project was based in a vacant shop and involved four inner city neighbourhoods of Cardiff. Working with residents having local knowledge, and inviting

people, including writers, poets, musicians and actors to speak of what they know of the area and its history, the project used radio creatively and transformed aspects of the everyday into radio plays, musicals, documentaries and soundscapes. There were also commissions for sixteen artists of various kinds working in sound and visual formats. Seeking to push the boundaries of artists' practice in all areas, with few limitations – other than the need to communicate with the communities involved – it culminated in a week-long broadcast in October 2005 and an exhibition, also involving an audio archive at the National Museum Cardiff. A publication documenting the project and Jennie Savage's work is available from CBAT (029 204 887720).

The Becoming Ground

Imagine a place to breathe, a thread of narrative that goes beyond the footsteps of today into the before-ground. Listen to the stories of the past, the paths trod navigating this space, this woodland canopy…. feel them merging into this moment. Sit still and breathe in this space and listen. The story will emerge… (Rawley Clay and Sarah Hilary-Jones)

Possibly the first Arts Centre to be selling electricity to the National Grid, Coed Hills Rural Artspace is a project with a vision of the future. It shows that, half way through the first decade of a new millennium there is a real possibility that Wales can now draw from the growing strength of its grass-roots organisations and feel empowered by the knowledge that they are contributing more to real sustainability than their more conventional counterparts.

Set up in 1997, Coed Hills Rural Artspace is an unusual setting for what is tantamount to an international art show. Upon entering the place, what strikes is how 'local' it is. A hundred and eighty acre farm, its galleries powered by electricity from a wind turbine in a field; the timber that fires the under-floor heating carried by horse from the woodland just yards away, the place is designed to avoid importing commodities across vast distances. Its art is a different matter and the greater the distance from which the artist comes the better. The underlying philosophy of this place is that for an artist to have travelled a great distance adds clarity to their vision, in their very alienness they see the place through new eyes.

The farm has hosted many artists over the years, and each one has taught us something about their culture, their eccentricities and their arts practice. What do they take from us? Some understand immediately, and for others the surprise at turning up, at what one could only describe as an eco-community, probably sends them back with some unique visions of the country. As one of the most unusual arts venues in Wales, Coed Hills gets a lot done. Artists have become roofers and foresters; visitors have become volunteers.

The project is run by a group of artists living on the land, in small, low-impact dwellings: railway carriages with straw bale extensions and the like. Its work – over the last decade – has been to create one of Wales' most cutting-edge woodland sculpture trails; taking contemporary work out of the white-walled gallery and into a natural environment. Not for Coed Hills the clichés of 'organic art' simply placed with an absence of any meaningful dialogue between artist, object and context. Nor does Coed Hills hark back to some pastoral idyll, such as might be favoured by some back-to-the-landers. This is 21st century high-tech living but with all the advantages of rural life. Its avowed aim in fact is to challenge traditional concepts of 'the rural', whilst championing all that is best from our heritage: 'Ancient futures' neatly sums up their concept.

Coed Hills' artists live on-site, sometimes within the woodland itself, exploring their ideas in a supportive artistic community. Each evening the day's work is discussed convivially, with multiple points of view constituting a critique – reforming and refining ideas. Staying on site is encouraged,

in order to ensure a seamlessness of vision between artist and land. Outcomes of a stay may not necessarily even result in a 'finished work'. Reflection, dialogue and process are seen as equally important and it is accepted that the results may take a longer time than the term of a residency to emerge, but in terms of the artist's progression, the process is vital. Coed Hills now has equipped workshops for wood, metal, textiles and print-making. A community sawmill delivers home-milled lumber to local artists and craftsmen (the greenwood working area recently supplied a Yurt to the Wales Millennium Centre).

A collaboration in 2005 between Legal and General, Arts and Business and Coed Hills generated fifteen pieces of new site-specific work in the woodland as a result of a winter of artists' residencies. Summer 2006 saw an exhibition of twenty-six international and local artists in the woodlands of Coed Hills. BREATHING GROUND is about the narrative of place, presented through the eyes of artists living on site who contributed to the exhibition (which includes Iwan Bala, Simon Fenoulhet, Peter Finnemore and Nadim Karam).

Rogelio Vallejo

G.R.O.U.P (Group Research On Urbanism & Performance)

G.R.O.U.P consists of performance and visual artists, historians, architects and writers who share an interest in the documentation and critique of art as public or civic space. In particular it seeks to tell stories about the forgotten and dispossessed who build and inhabit the urban visions of political elites. The desire to harness urban construction in the interests of nation building is the most immediate manifestation of this utopian impulse and is revealed in the construction of new parliament buildings such as that of the Welsh Assembly and the Scottish Parliament. At its most ambitious, it was seen in the construction of new capital cities (such as Brasilia, Canberra, Chandrigarh, Abuja and most recently, Astana in Kazakhstan) on virgin sites.

G.R.O.U.P (a conG.R.O.U.P.sortium of Dartington College and Cardiff, Duncan of Jordanstoun and Glasgow Schools of Art), aims to revisit these places and, through a series of co-ordinated performances, live actions and writings, consider what lessons they may hold for the future of political democracy and urban construction.

Wales at the 2005 Venice Biennale

SOMEWHERE ELSE: artists from Wales received much critical acclaim at the Venice Biennale of Art. Their choice proved very popular within Wales too. In addition to the exhibition by Peter Finnemore, Laura Ford and Paul Granjon, there was also a residency by Bedwyr Williams, a partnership between Wales at Venice and Cywaith Cymru. All three artists made new work for the exhibition and Bedwyr Williams launched his book: *BASTA* (Enough), which he produced during the residency. The exhibition's theme was approved by the committee from amongst several suggested by the curator, as a result of background research, including a call for information and extensive studio visits throughout Wales. Original members of the management committee (officially a sub-committee

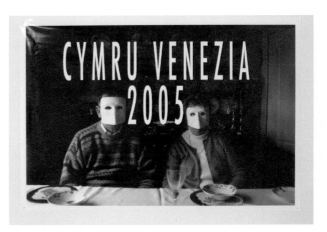

Bedwyr Williams BASTA Posters (2005) (Image: Polly Braden)

of the Art Council), Gwenllian Ashley, Martin Barlow and Hugh Adams, are now stepping down, having served for the maximum term allowed of two biennale. Michael Nixon continues as Commissioner for Wales with Hannah Firth the new curator who succeeds Karen MacKinnon. Visual Arts Programmer at Chapter, Cardiff for the past five years, Hannah has curated numerous exhibitions, including (in 2005) an exhibition of seven Welsh artists' work for the Contemporary Art Centre in Vilnius, Lithuania, Olaf Breuning's THEY LIVE and shows of André Stitt and Bedwyr Williams.

Furthermore... It is often asked 'what are the knock-on effects of artists' exposure at Venice?' Of those involved in Wales' two previous Venice showings:

Peter Finnemore, who kindly made us a present of his artist's 'intervention' in this publication, has been invited to participate in the prestigious Barcelona Video Festival and to a show on 'humour in art' at the State Gallery, Kansas. He is also showing at the Gallery Boreas in Brooklyn, New York in late 2006; Cerith Wyn Evans exhibited a version of his TRANSMISSION: VISIONS OF THE SLEEPING BARD at the 2005 Istanbul Biennale of Art; Paul Seawright had a major survey of his work at the FotoMuseum in Antwerp; Simon Pope has been supported in his 'ambulantscience' projects by the BBC, Arts Council England and the Wellcome Trust's SciArt Research and Development Fund; Bethan Hughes has been nominated 'Laureate' of the biennial BACA European Prize (this consists of Euros 50,000, plus an exhibition and publication); Laura Ford showed her Venice work at Canary Wharf Tower; Paul Granjon is undertaking a residency in Canada and exhibited his Venice robots in Ljubljana, Slovenia. He has also been offered exhibitions in New York and San Francisco; Bedwyr Williams now has The Store Gallery as his London representative and he has a residency in Toronto and a solo show at the Collective Gallery, Glasgow in 2006.

Ironically Disappeared

Just at the time it was poised to celebrate its twenty-fifth anniversary and had published a record of its considerable achievements (the artist Mary Lloyd Jones referred to it as a "national treasure"), Cywaith Cymru has been 'disappeared'. This is not in itself of great significance, as it will be merged with CBAT (the Arts and Regeneration Agency) to form a new organisation. The Arts Council 'indicated' that it was minded to merge the two organisations and when the Cywaith board of trustees resisted, turned off the funding tap and began establishing a new company to take over the functions of both organisations. Another brave day for democracy in the Welsh arts scene! Also, unprecedentedly, the Arts Council itself advertised for a chairman for the new and, as yet nameless, organisation. Harry James, recently retired from Arts Council membership, was appointed.

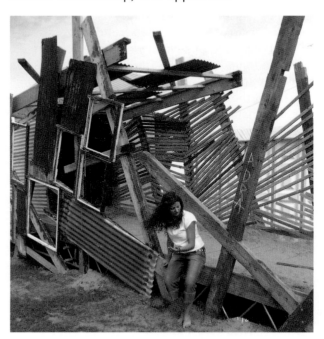

'Noddfa' Cywaith Cymru's artStructure at the National Eisteddfod, Eryri (2005). A collaboration between artists Helen Jones and Sean Curley with performance by writer/singer Gwyneth Glyn

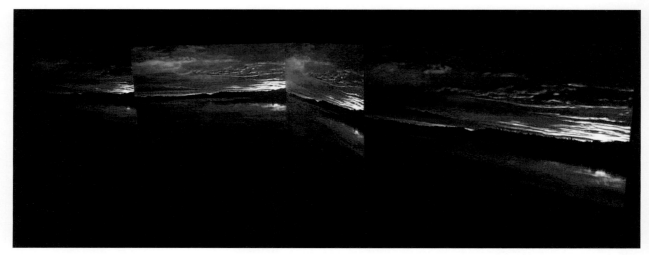

Eija-Liisa Ahtila 'Hour of Prayer' (2005) Photo: Jeff Morgan

Artes Mundi

Adi Eija-Liisa Ahtila, based in Finland, became the second recipient of the Artes Mundi prize. 'Hour of Prayer' was one of several works she presented at the National Museum, Cardiff as part of Artes Mundi's overall programme of activity which included the exhibition of shortlisted artists' work, an international conference and a fund to purchase work for the national collections.

Eight artists, including Cardiff-based Sue Williams, were on this year's shortlist for the £40,000 prize. Among the international panel of selectors was the Curator of the Glynn Vivian Art Gallery, Jenni Spencer Davies. Now, the second time the prize has been awarded, it is accompanied by a much more coherent interpretive and educational programme, including an international two-day conference on cultural 'geo-positioning', held at the Glynn Vivian Art Gallery.

Small Talk, High Heels

is a Glynn Vivian Art Gallery touring exhibition of of Artes Mundi shortlisted artist Sue Williams.

Seen in Swansea and at the Mostyn, the show is accompanied by a publication (72 pages, full colour, £7.50), with texts by Sue Griffiths, Ivo Mesquita and Sadie Plant.

Grace A-binding.....

The results of Philippa Lawrence's Creative Wales Award last year have been plain for all to see. She writes of her ambitious thirteen-part work 'Bound' and its raison d'être:

"I used to be a 'city girl'. Times change and the past three years of regular travel across Wales has drawn me inextricably to the country. Over time, quietly, almost 'unnoticed', I found myself woven to the land, developing a personal and deeper understanding of the countryside.

On journeys and walks I began thinking about the reference points that would once have served as markers for travellers and those defining their home and its boundaries. I became drawn to churches, ruins, ancient clumps of trees, stone walls, and bridges in fields seldom visited. I began to learn about the land and the way it has been shaped by man and industry.

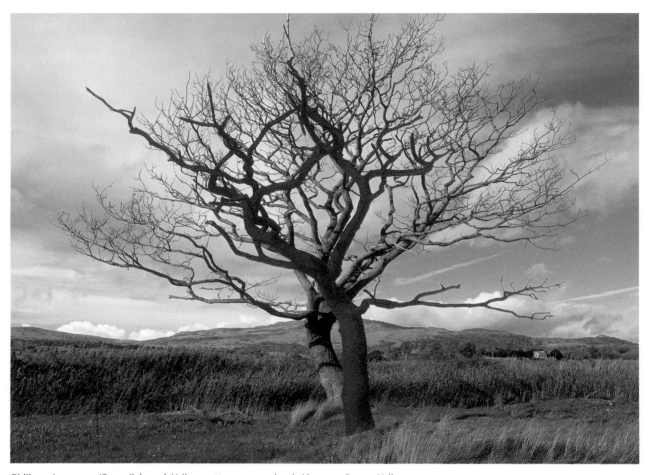

Philippa Lawrence 'Bound' (2004) Yellow cotton wrapped oak Maenan, Conwy Valley

Whilst not Welsh, I have found that Wales has entered my psyche and my spirit and I would be delighted if I thought I could make a work which referenced and celebrated the land that supports me. There are thirteen 'old' counties of Wales; Anglesey, Brecknockshire, Caernarvonshire, Cardiganshire, Carmarthenshire, Denbighshire, Flintshire, Glamorgan, Merioneth, Monmouthshire, Montgomeryshire, Pembrokeshire and Radnorshire. My project was to explore and to locate an ancient tree in each of the counties that could be wrapped and documented. The work develops previous ideas in which the commonplace, everyday and overlooked is re-presented to the viewer as an icon.

For me the success of the first 'Bound' in Carmarthenshire (as part of EXPLORATIONS at the National Botanic Garden of Wales in 2003) was in its ability to reach and connect with the public. The stark, white elegance of this bound dead oak tree, already a much loved and revisited landmark in the gardens, drew the gaze and imagination of subsequent visitors. References were made to antlers, lightning and to fungi, to mummification

and to swaddling. There was amusement and enjoyment. People were compelled to touch its trunk, none passed it without comment.

I can trace my interest in 'wrapping' to Milton Keynes in 1987, when I went to visit an exhibition of Japanese packaging and product design called FIVE WAYS TO WRAP AN EGG. In 2002 I went to Tokyo and Kyoto and this time it was cloth and paper – tied to wooden poles outside the temples that 'spoke' to me.

I wished to return to the woods and trees which our road system now passes by and, in each of the old counties of Wales, explore and wrap a dead tree in an act of veneration and meditation on its (and our) past, present and future. I thought it important to be able to see the trees from the road, or from a well-worn path, so that the audience would be those that pass by, or through, the area.

This deceptively simple project offered enormous scope for research and collecting historic information and for making very real connections to the land and with local individuals. The strong imagery, varying with the seasons, the quality of light the materials used such as linen and cotton might be documented and shown as a publication and as an exhibition that would equally suit a gallery situation, or a community venue.

To go full circle and to make a similar work in Japan would be my ultimate goal, but for now I see the project in Wales as an entity in its own right. The work is visible and in the making and when completed, will help to develop and improve the knowledge, understanding and practice of art in Wales, via its manufacture, documentation, exhibition and, I hope, enjoyment."

If you go down to the woods today

I have arranged to go to the Freud Museum with Paul Emmanuel. It should be an interesting visit, considering the fact that one of Emmanuel's ongoing projects is PSYCHO, a live intervention between the artist and Dr Richard Maggs, psychoanalyst. I have only seen PSYCHO on video, but I feel I know the piece almost inside-out, though I'm sure Dr Maggs would have something to say about that.

This is how it goes: Emmanuel lies on a couch protected by plastic sheeting. A video camera is positioned above his head, the lens over his mouth, the viewing screen turned towards the artist and connected to a large projector on a nearby wall. Dr Maggs is seated close-by, poised with pen and paper, quietly studying a case file. It is a bizarre set-up already, but things are about to get stranger: next to Emmanuel are several tubes of acrylic paint, uncapped and just asking to be squeezed. Emmanuel considers the tubes and decides on a nice Carmine Red to start. He places the tube between his teeth and the paint begins to ooze out. Dr Maggs begins to question Emmanuel: Growing up, did you get on well with your parents? / What qualifications did you leave school with? / Apart from alcohol, what other drugs do you use? Emmanuel tries to answer, but his mouth is full of paint and spittle and he is making funny choking noises. (Is he alright? wonder the audience. Shouldn't someone call an ambulance?) Dr Maggs looks unconcerned and continues his questioning, whilst Emmanuel, having emptied the contents of Carmine Red, discards the tube and reaches for another – now a bright yellow mingles with the red and the image projected becomes more abstract, a study in marbling perhaps. More paint is squeezed out and more tubes inserted into Emmanuel's mouth: white, black, blue, green, and the audience is mesmerised. It is grotesque, the sight of all that paint in his mouth and throat, but it is also enthralling and the projected image is viscous, visceral and beautiful. About 45 minutes have passed when the questions stop and Emmanuel shakily sits up. The crowd is stunned but after a moment, enthusiastically applaud and Emmanuel is asked a whole new set of questions: Do you

ever swallow the paint? / What's your favourite colour? / Apart from alcohol, what other drugs do you use?

PSYCHO is the culmination of a three-year body of work which began in 2001 when Emmanuel was selected for a three month British Council residency in Taiwan. At the time of selection he was producing large-scale body paintings and was deeply involved with what he calls "the vital stuff of painting – surface and tool". The marks he made were deliberate and erotic: 'Cockfish' needs no explanation. With a knowing nod to psychoanalysis, he enjoyed playing with paint, decadently squeezing out whole tubes into messy turd piles, smearing it over himself and the canvas, luxuriating in its physical likeness to shit and aware of the repulsion this effected on gallery audiences.

psychologically. A year after he returned to Wales the Glynn Vivian Gallery showed new work directly influenced by his experiences: a slideshow of negatives of Taiwanese cityscapes was frighteningly blank, flat and nightmarish; his video paintings were clownishly disturbing, showing tubes of paint squeezed out in the artist's mouth. PSYCHO was born soon after this exhibition.

Parallel to his collaboration with Dr Maggs on PSYCHO, he began to manipulate his other video paintings, dividing, halving, mirroring images in a surreal echo of Dr Hermann Rorschach's ink blot tests. Dr Rorschach's original ink blot tests (ten cards, half in colour, half in black and white) were developed in an effort to reduce the time required in psychiatric diagnosis and theorised that what you see in the ink blots is a reflection of your fan-

'Hand to Mouth' Acrylic and digital video

Emmanuel had also started to explore video as a form of painting itself – the video screen became a canvas, transforming painting into a living, breathing embodiment of the process. The images were sensual, accompanied by comic farting noises as the paint bubbled and popped out of tubes squeezed empty in his fist. He was excited at the prospect of spending time in Taiwan, but it was tough: the living quarters and studio were bereft of such luxuries as furniture, curtains and a fan to shift the air in the heavy 40 degree heat. He struggled with the 'Chinese mind-games' admitting his time there affected him greatly, both physically and

tasies, your personality and your current mental state. In Emmanuel's video paintings I see monsters with green horns, eyes blinking and then gone a moment later, mouths devouring ice-cream sundaes and butterflies hatching out of their pupae, but what does Emmanuel himself see? "Beautiful things," he says. One painting in particular is entrancing: twelve miniature tubes of paint, filmed in infra-red and then looped and reversed, so the tiny piece surges out towards the viewer and then imperceptibly implodes to start all over again. It is filmed at night, outside Emmanuel's farm in Wales, with a soundtrack of

grass and trees and birds and is from a new series of paintings filmed in domestic spaces, perhaps a metaphor for the internal dialogue of the artist and his psyche. Although it is difficult to recognise the environment on the edge of these abstract images, there are glimpses of a kitchen table; the garden; the living-room carpet.

At the same time, Emmanuel is making 'real' paintings: actual paint on canvas. The paint is piped onto the canvas like oversized icing on a cake; first one way, then crisscrossed over so the effect is a huge magnified square of cloth, the warp and weft woven in paint. These homely references are not intentional, but combined with the pared-down scale of 17.5x12.5x7.5 cm, they allow for an intimate reading. To the romantic, they could allude to his recent marriage: the thick, pliable paint on the canvas foundation will take years to reach its final state, but from the beginning the painting is a complete unit that hopefully will stand the test of time. It seems Emmanuel has turned a corner in his life – he was invited back to Taiwan in 2004 for a shorter residency, which he finished off with a performance of Psycho. It was a nice circle, to be performing back in the place that had triggered so many thoughts and feelings three years earlier. After that concluding visit, there was a dotted line drawn under those years of work and a move towards a more stable practice informed by the artist's current environment. This doesn't mean to say we've seen the end of Psycho, just that it doesn't hold such a pivotal role in the development of his new paintings.

It is almost 2.30pm; I have just seen Paul exit Finchley Road tube station resplendent in a 70s-inspired brown leather jacket and smoking a roll-up. He looks quite normal. He spots me, waves and strolls over, quite unconscious of the thoughts that have been going through my head for the past few minutes. Above all, I am now wondering what will come of our visit to the Freud Museum? Perhaps we ought to have had a picnic instead.

Sara Gillett

The Jerwood Artangel Open

This is a new £1 million commissioning initiative for the contemporary arts in association with Channel 4 and Arts Council England. This fund will make three outstanding new commissions possible. Proposals are invited from arts practitioners to respond to specific sites and situations across the UK. "Arts practitioners" includes (but is not limited to) visual artists, film-makers, choreographers, composers, writers, theatre practitioners, applied artists and producers living anywhere in the UK. At this stage they are not looking for fully worked-up project plans or budgets, but for bold and brilliant ideas. Application forms and guidelines are available from www.thejerwoodartangelopen.org.uk.

The prestigious Jerwood award for Photography was awarded to Cardiff-based Richard Page (see page 101) in 2004.

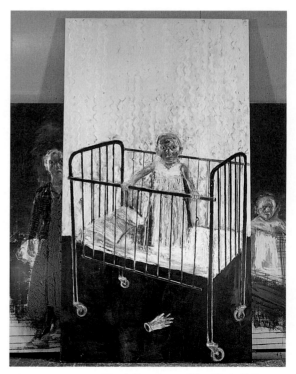

Shani Rhys James 'The Black Cot' 2003
Oil on Linen 6.6m x 3.6m Photo: Graham Matthews

Shani Rhys James, who received an MBE for services to art in Wales in the New Year's Honours list in January 2006, won the Jerwood Painting Prize, her painting 'Black Cot and Latex Glove' was acquired by the National Museum in January 2006 and Gomer published a monograph about her; she also received a Creative Wales Award, 2004-05.

Saved! Visual Arts at the Eisteddfod.

Public clamour means the visual arts at the Eisteddfod received a reprieve after their future was put in jeopardy by a 'cost-cutting exercise'. For the first time the ACW and the National Eisteddfod planned a joint pavilion, with ACW contributing £35,000 to the cost. The Visual Arts Pavilion is an integral part of the Eisteddfod and is a showcase for Welsh artists as well as being a focal point for anyone interested in experiencing the latest contemporary work. In addition Cywaith Cymru has, for a number of Eisteddfodau, organised a compelling programme of artists' 'residencies' and installations. Sian Tomos, Director for the North Wales Office of the Arts Council, said:

> The Pavilion is an important and vibrant forum for the visual arts from the whole of Wales and the work on show has a real cutting edge. The work on display... goes beyond language. It's about a sense of belonging, the idea of place, home and aspirations... it's a testimony to our belief in this work that we have contributed so many of our resources in order to sustain this very special visual arts space.

The Eisteddfod's 2005 Gold Medal for Art was awarded to Peter Finnemore. Elfyn Lewis (page 88), curated a special exhibition on artists' depictions of Snowdon.

The Henry Moore Foundation

Has revised its grant-making programme and published new guidelines. These indicate increased financial resources to support living artists and art practice. Special emphasis will be placed on projects outside London and to venues with limited opportunities to show contemporary art. Other grant-aid categories remain much the same as before. More information: contact via the Foundation's website, or contact the extremely helpful Mrs Anne Unthank, The Henry Moore Foundation, Dane Tree House, Perry Green, Much Hadnam, Herts SG10 6EE.

The Esmée Fairbairn Foundation

Is one of the largest grant-making bodies in the UK and last year distributed over £29 million to arts, heritage and social charitable purposes. It now has the visual arts as one of its key areas of benefit and, until April 2008, will focus primarily on the contemporary visual arts including architecture, crafts, design, fine art, new media, photography, public art and sculpture. They are particularly interested in visual arts proposals that fit one or both of their main funding priorities: 'Serving Audiences' and 'Supporting Artists'. The foundation has extremely clear and useful guidelines on its website, which say that it is anxious to achieve an even geographical spread of grant-aid and one of the areas identified as under-represented in its programmes is Wales.

Other news

Tamara Krikorian left Cywaith Cymru in September after having been Director almost since its inception. She intends to continue working freelance from Penarth, where she lives and is writing a book on Peter Bailey (see obituary p56).

Nicolas MacDonald has also left Cywaith Cymru to become Cultural Strategy and Partnerships Officer for the City and County of Swansea

Sally Moore, who lives and works in London but was born in Penarth (see profile p98), won the Welsh Artist of the Year award 2005. It was presented at a ceremony at St David's Hall, Cardiff. Grace Davies has returned to Ffotogallery and is collaborating in the organisation of LOCWS 3.

Alms in secret?

Both the Colwinston Charitable Trust and the Derrick Williams Trust have been of instrumental importance in supporting the visual arts in Wales and yet it seems to take forensic research skills to track down anyone responsible for correspondence, or published grant-aid criteria. We hope in the 2006/07 Year book to give both an opportunity to report on their activities in recent years and advise possible beneficiaries of how they might be approached.

University of Glamorgan forges ahead:

Ernest Zobole & the Visual Culture of South Wales since 1945 is a project run by Ceri Thomas, research fellow and curator of art at the University of Glamorgan. Its primary aim is to research, catalogue and present the work of Ernest Zobole (1927-99) within the context of the visual culture of South Wales.

He writes: Zobole is the iconic painter of the Rhondda Valleys, the engine-house of the industrial revolution which powered the British Empire, and he is widely considered to be one of the major visual artists of post-war Wales. His career spanned the whole of the second half of the twentieth century, during which his chosen landscape rapidly de-industrialised and his art underwent several dramatic changes. These were presented in ERNEST ZOBOLE: A RETROSPECTIVE, a major exhibition which was curated by Ceri Thomas and toured Wales in 2004-05. His monograph *Ernest Zobole: a life in art* is to be published by Seren in 2007.

Since May 2002, the university's Zobole Gallery has shown a series of small, contextualising exhibitions, drawing upon the University's substantial Ernest Zobole Collection. Currently underway elsewhere on campus is a programme of new displays of two- and three-dimensional works by artists from, or active in, south Wales since 1945 and represented in the University's growing art collection.

NMW Cardiff

Although the National Museum in Cardiff remains open to the public, some galleries closed in May for a major refurbishment programme funded by the Welsh Assembly. Essential work is being carried out and they reopen for the Museum's centenary in 2007. For updated information see their website or phone 02920 397951.

Artists' Training

Cardiff-based g39 gallery is an artist-run organisation committed to supporting artists in Wales. Exhibiting Welsh contemporary work alongside that from further afield, it plays a key role in sustaining networks between artists. Operating catalytically, its Artists' Professional Development Programme aims to "strengthen the visual arts sector through good practice and information sharing". By dealing with such things as questions on funding, artist-led activity, strategies for approaching galleries and providing feedback on current practice, its schemes enable dialogue between itself and artists, whilst providing it with an overview of new work in Wales. Although Cardiff-based, the gallery runs 'surgeries' throughout Wales and artists feeling they might benefit should contact Projects Officer Michael Cousin: Telephone: 02920 255541; email: mike@g39.org; www.g39.org.

Alternative Dialogues: inter-cultural exchange – through cooking

2005 artist-in-residence, Owen Griffiths explains some unwonted flavours at The Mission Gallery in Swansea:

"For some time I had been developing a series of live action works involving serving soup to people and was interested in how cooking was a kind of parallel creative process, involving warmth and chemical change to create something not only visual but sensorily ritualistic. Part of my residency

involved working with a group from Swansea Bay Asylum Seekers. Without having to ask them directly, I was keen to learn about their experiences of leaving homes, cultures and usual lives. I felt a need to work with them in a creative way, one which wasn't asking them to draw, or even create, an 'artwork' but rather approach the idea from a new perspective.

I transformed the space into a temporary kitchen, constituting a new type of forum where skill, culture and knowledge could be demonstrated and exchanged. Integral to each of these processes is warmth. Without warmth nothing happens. I saw the kitchen as a 'warmth instrument' and the food as a communicative tool, with which we could make people feel at ease and comfortable, whilst they indulged in familiar tasks and tastes. The Mission Gallery context provided a framing for every action and elevated every meal and accompanying experience into a new dimension, one in which an alternative dialogue was happening. Every day a different person would cook and each would come from a different country; we all ate every meal together. This holistic approach to talking about culture, asylum and leaving one's home was never really broached

directly but through this simple mechanism, we created a shift in the imagination of both participants and viewers. I am much influenced by the legacy of German artist Joseph Beuys and see this project as a 'Social Sculpture'; ie an artwork which works with people and promotes art's extensive capabilities and its potential to change the world, whilst simultaneously celebrating the fact that all human beings are artists."

Arts Training Wales

Zoe Rozelaar and Donna Jones have become co-directors for an interim period, upon the departure of Cathi Marcus to work for UK National Parks. Nia Metcalfe, Information Advice and Guidance Assistant, will support client services.

Why Are Artists Poor?

Hugh Adams reports and reflects on an acronym-laden International Cultural Compass conference and issues around examining the economic status of artists:

The conference 'addressed' – using its language – the question of "why are artists poor?". It included representatives from all over Europe from arts and cultural organisations, most of which most of us had never heard of, as well as trade unions representing those working in 'cultural industries' (few of these will have been heard of by most of us either). The detestable habit, infection really, of solely acronymous reference, tout court, to such unlovable arts and cultural bureaucracies is not only linguistically unlovely but bankrupt in terms of the conveyance of useful information. I have eliminated reference to them here, as meaningless to me and probably to the sane reader too.

There was preoccupation with results of a study, punchily entitled: "Various regimes of employment and social protection of cultural workers in the EU". This includes chapters on the situation of artists of all kinds in the EU (with the exception of Luxembourg, for some reason). The

Owen Griffiths and friends at the Mission Gallery

report emphasises the need, not only to develop some kind of standard definitions for describing artists but also to acknowledge that artists are usually, though not necessarily, self-employed and hence need to benefit from tax-relief schemes, as well as maintain artistic independence. Artist readers here will not be surprised at the identification of varying degrees of arbitrariness experienced by artists in dealing with tax authorities in the UK and the singling out of our tax authorities for their lack of enlightenment (many of us would say their inconsistency too). Generally the legal framework in which artists operate in Europe is 'elastic', meaning that artists find themselves subject to the whims of administrative and legal interpretation, affecting not just their ability to access state aid but to even be considered 'an artist'.

European competition authorities are increasingly viewing artists as 'Single Member Enterprises' (more linguistic bankruptcy!), rather than self-employed, meaning that they are denied the right to form unions. This has occasioned great concern in the more enlightened countries of Europe but is rather hypothetical in Wales, where, since the demise of the Association of Artist and Designers, there has been nothing even approximating to a professional association serving the interests of self-employed (or any) artists, let alone a union.

The conference focused chiefly on visual artists and writers. Among the conclusions reached were: the 'problem' that not all who call themselves artists produce good work. However subjective this response might seem, it was also said that many very good artists remain poor (which is true) and always will be (which is not, surely, axiomatic!). An additional complication is another we might ponder in Wales: the 'over-production' of artists. It is argued that the number of artists in Europe is growing and training and educational establishments offer too many places, when there is not enough work available to sustain the market. However, an argument I have heard against this is that not all who graduate with Fine Art degrees consider themselves (or consider themselves to have been trained as) artists but rather have acquired those elusive things 'transferable skills'. We might well examine the mythology here and the expectations of students on entry, set against their actual educational experience. Qualification-related occupations – within two years of graduation – which are cited in Higher Education Funding Council statistics are, one feels, too imprecise a measure of the realities. There is a lot of unpicking to be done here; but in whose interests is it to do it?

Despite the burgeoning of 'continuous professional development' and other forms of 'Life after art school' offerings (few, if any, effective ones in Wales), it was asserted that, in general, artists and students receive very little training in business skills and particularly in dealing with issues relating to tax, insurance, pensions, marketing, contracts and unionisation. Some art forms fare better than others in this. The Writers Guild of Great Britain has established a presence in colleges to raise young people's awareness and clearly, unions such as Actors' Equity have long been effective in enforcing some 'professional standard of entry', as arbitrary as these can often seem. The UK was cited as a country in which visual artists are isolated as far as professional standards are concerned but unions in some countries have been able to establish such things as minimum working conditions and re-sale rights for visual artists, so far unknown in the UK. Again this seems hypothetical in the case of Wales where National Artists' Union membership is dismally low, if at all existent (at my last enquiry, admittedly some six or seven years ago, it was 'maybe three!'). Without enforceable professional standards, visual artists remain prey to galleries that charge them absurdly high commissions ranging from 50 to 75 percent, with artists often meeting all the costs of exhibitions, including catalogue

production. Even Exhibition Payment Right, for all its inadequacies and which was engendered by arts bureaucrats rather than artists, seems to have withered on the bough. In the UK, as abroad, possibly in response to this, but also in an attempt to seize control from the culture of curatorship, many artist-run galleries, operating on a co-operative basis, have been established.

Other problems identified were artists not having sufficient continuity and security of employment; in the absence of a consistent 'patron', and even then, the likelihood is that an artist will always lack security. Ubiquitous, as we all know, are 'successful' artists, who yet continue working full-time only with partner support, or some kind of part-time job. The complexities of 'Portfolio' and 'Kaleidoscope' working, seem to have eluded conference contributors, though in Wales in particular, this is widespread practice and, as my editorial here on 'incestuousness' indicates, sufficiently so as to constitute a cultural, if not practical, problem. Oddly, in Wales there has been extensive, though not recent, research on artists and how they survive economically. I think of Emma Geliot's survey for the Old Library Artists Group and Nicholas Pearson and Andrew Brighton's seminal work on 'The Economic Situation of the Visual Artist' for the Gulbenkian Foundation. However, for more recent material one has to rely on the likes of Dr Janet Summerton and her former colleagues at Sussex University.

Other points of interest arising: unionised, artists can negotiate some kind of minimum terms of employment and much better conditions. However there is a certain 'climate of fear': a gallery can easily bully self-employed artists into signing an unfair contract or not even offer a formal contract at all; which is very common. Due to defamation laws it is almost impossible to publish comparative rates for remuneration, or make publicly-known those galleries offering unfair contracts. Word of mouth and informal information chains alone inform artists of unfair practice. Anti-competition laws do not help the plight of artists and in fact it is only German contract law which encourages the self-employed to organise into unions, to negotiate minimum terms with employers and even this may be deemed against EC interpretation of what constitutes 'competition'. This situation will get worse, with the eventual adoption of the Services Directive actually reinforcing the notion of self-employed artists as 'businesses'. The conference felt that more importance ought to be attached to a twenty year-old definition by UNESCO, in which an artist is deemed a self-employed worker, with the right to join or form unions and campaign for minimum terms of commission and employment.

The implications for artists are significant. Clearly Wales as a beneficiary of EC membership will want to assert the rights and needs of its artists in whatever appropriate forum might offer itself. However, first it needs to elicit what these might be. The series of peripatetic Cardiff Symposia, in which artists in Wales were invited to articulate what they saw as professional necessities, needs revisiting, its conclusions updated and published, in order to inform a long-overdue debate.

That appropriate infrastructural provision needs making, and the almost complete absence of training and CPD in Wales must be remedied, goes without saying.

Trace: edited by André Stitt £12.99pb Trace is the only gallery in Britain devoted solely to time-based art. In the first five years of its existence, it has hosted artists from around the world. This book documents the Trace programme, its energy, anger, humour and subtle inquisitions. Critic Heike Roms positions Trace in the context of performance art in Wales, while artist and theoretician Julie Bacon considers how time-based art is able to transcend the standard models of Western culture.

The Painter's Quarry: the art of Peter Prendergast £25.00hb In a career spanning four decades, Peter Prendergast has established himself as one of Britain's foremost landscape painters, and as a formidable painter of portraits and self-portraits. His bold, expressionist style has resulted in thrilling drawings and paintings of the mountains and fields, seas and rivers, quarries and towns around his home in Deiniolen. These subjects, along with Ireland, New York, and most recently, seascapes from the rocky cliffs of South Stack in Anglesey, are celebrated with vigour and energy by essayists including Tony Curtis, Peter Wakelin, Lynda Morris and David Alston.

Return/Yn Ôl Rhodri Jones £20.00hb Born in Gwynedd, Rhodri Jones grew up speaking Welsh, English and German. For the past two decades he has travelled widely in Latin America, Europe, Africa and the Far East, building up an astonishing portfolio of images ranging from the mountains of Albania to the cities and deserts of China. Now based in Italy, he has turned his lens on his country of origin. Jones has a unique perspective and a freshness of vision which make his work compelling and illuminating.

Groundbreaking edited by Iwan Bala £19.99pb Cywaith Cymru was among the very earliest bodies to promote public art in Britain. This landmark book assesses and celebrates the first twenty five years of an organisation which has pioneered the development of theory and practice in a challenging, vital field. Artists and critics consider the concept of public art, exploring past trends, current thinking and future orientations, as well as the cultural contexts in which public art takes place.

www.seren-books.com

art | biography | criticism | drama | fiction | poetry | politics | photography

Puritanical Voyeurism

Holland is a studio painter mainly of individual figures, nude, not-so-nude and clothed, but occasionally also of groups which he melds together from individual poses. There is in almost all of his pictures a nod – a tentative one mostly, a shoe here, a handkerchief there, a wistful gaze or knowing look – towards narrative, though it is the formality of painting what is in front of him which is more the subject of his work than any desire to tell stories. He is a voyeur, a looker, a conveyer of information about the spartan settings in which models self-consciously pose. He gives almost nothing away. His paintings, smoothly executed in small, nearly invisible brushstrokes, are a compendium of observed accidents, of how a highlight has elongated across a ridge of flesh and textures have varied. Indeed, the way in which light has burned white a leg or a material often assumes exaggerated importance in the context of an otherwise elusive subject. Part of the job of the painter and draughtsman is to look concentratedly and to encourage us to do the same. Holland's gaze reminds us how infrequently we actually interrogate closely what we are looking at.

Drawing is the first stage, in books and on individual sheets. Characterised by an unpressured facility, these drawings are rarely, if ever, exhibited or sold but they are, to my eye, Holland's freest, most uninhibited and natural work. Then comes a small oil sketch, once again free and speculative, sometimes with pentimenti, the paint thicker, the touch of the brush more assertive and with an experienced summariness which Holland suppresses in the finished picture. At this stage the sketch is put away, sometimes for as much as six months. This rest enables him to forget it and then to look at it afresh and to make adjustments before commencing the full scale picture. The process of using models continues throughout all stages and many months may elapse before

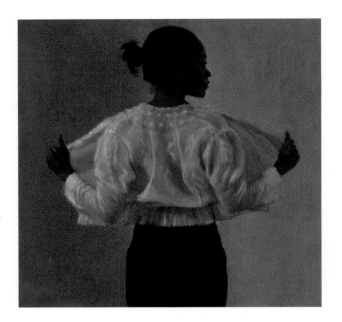

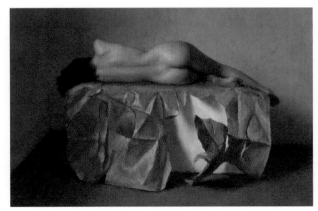

'Blouse' (2005) oil on panel 34 x 32cm
'Tear' (2005) oil on panel 38 x 55cm
(courtesy Martin Tinney Gallery)

something tolerable materialises. Occasionally the process is aborted and a picture abandoned and destroyed but, because he works compulsively every day, Holland is nothing if not highly productive. Holland is living testimony to the continuing diversity that is painting and to the equal diversity of the audiences which exist for work in all styles

David Lee

Being and Becoming...

Paul Hurley is typical of a new art animal: a hybrid in which animateurialism, curatorship and artisthood appear seamlessly to fuse. Allied with this is a disposition to collaborate and determine alternative modes of presentation. This 'collegiality' is almost a political commitment.

Self-interpretation, identity and difference are at the core of Hurley's art. His performances contain a series of virtual 'framings' which serve to highlight various conventions of representation. In his reading, lecturing and performing, there is an elision of presentational conventions, as action/performance and its interpretation become one. His is a direct but ultimately complex art which refers not merely to queer sexuality but sexualities and the various cultural codings within which they operate. His re-presentations and re-framing encompass a consideration of how differing viewpoints – 'reconceptions' – exist outside 'normative' value systems. That he extends himself physically (as he does his audience intellectually), is of the essence. 'Becoming' (in which he 'becomes', in each performance, an animal or invertebrate) are rigorously researched and bring pain and physical risk. His physicality – the body stretched to its utmost – and sexuality elide with other forms of sensuality: the combination considerably increases the tension in his audiences. The work can be appreciated as sheer movement, but to comprehend its full meaning and field of reference would call for an intellectually challenging reading programme. However, it is his avowed job to predigest, to a large extent, this material for the audience and, in his highly catholic practice as theoretician-artist-interpreter, he does it brilliantly. What we can only call his craftsmanship, is perfect. Hurley is a significant and substantial contributor to an internationally-appreciated element in contemporary art in Wales.

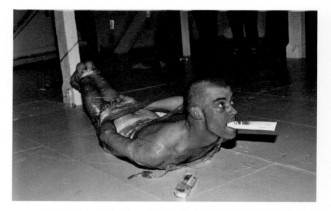

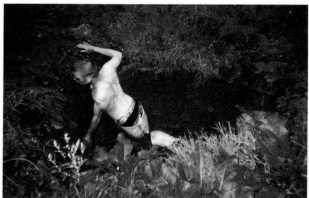

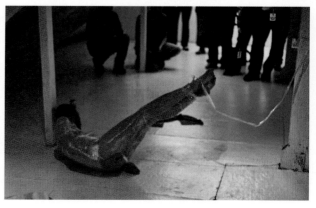

(top and bottom) 'Becoming Slug'
(middle) 'Becoming Earthworm'

Rogelio Vallejo

Memory and Reinvention

No-one underlines better the continuous development of the creative eye over a lifetime than Bert Isaac. Right up until his death in March 2006, aged 83, he was still painting energetically and obsessively, with a vital enthusiasm for the work that would be done tomorrow. Over the years his painting underwent a gradual revolution, from a linear form of watercolour drawing, reminiscent perhaps of John Minton, to a deeply painterly idiom which celebrated colour and was vibrant with gesture and freedom.

Isaac was born in Cardiff in 1923, grew up amid the mining landscape of Glamorgan and studied at Cardiff College of Art under Ceri Richards. After an influential teaching career culminating with his appointment as Head of Art at the London Institute of Education, he returned to live in Abergavenny. His principal subject throughout his career was nature's regeneration of abandoned places, particularly quarries, derelict settlements and industrial wasteland – landscapes that seem strangely beautiful and excitingly unsafe.

He used serendipity to unlock the sensations in memory of places he had known. Everywhere are slashes, flecks, stabbed lines and textures, suggestive of plant growth, wind and movement, or underlying structure. He worked fast, without interrupting the immediacy of reaction. In his pictures, derelict structures and detritus rest in static opposition to natural re-growth: roofless buildings, broken ladders, rail wagons, rolls of wire; but verdant saplings spring up in absurdly hostile places, amid quarry faces, or on old roofs, emerald reeds thicken around the margins of the ponds and water birds bring noise and movement.

In effect, Isaac created a unique and personal imaginative world, in which he meditated upon the landscape's infinite capacity to re-invent itself, and through that signified a kind of resurrection and redemption. In their own quiet way, these pictures have something important to say.

'Lost Garden' (Y Tabernacl Collection)

Peter Wakelin

Restored to Life

It is a strange business looking at Cecile Johnson Soliz's work, because you do not quite know what you are looking at. PROPERTY OF A LADY allows you to look at individual pieces, to look at the arrangement of a group of pieces in each section, or to look at the overall composition. I started off looking so confidently but came to lose my way, lost in its blankness, unsure of its date, provenance or function, all the criteria which art history and the auctioneer in particular, value.

Her work is increasingly provocative in the demands it makes of its audience, letting them loose and unsecured in the shifting sands between art and craft, painting and sculpture, object and image, one and many. At her first exhibition, in 1989, she showed sculpture in a context that might be described as painterly. Painting and sculpture are always contiguous for her, and she uses the wall as carefully as a painter would use the canvas or the frame. Putting objects against the wall is at the core of her practice, and is what she calls still-life. Making shelves for her objects is a way of extending the plinth question, while at the same time putting her objects into pictures and controlling their shadows.

The physical is always just below the surface: the warmth, the question of touch, the openness, the relating of one to another. The descriptive anatomy of a jug echoes the human; the size and shape of crockery reflects our hands, as do the tools which help to make them. The symmetry or asymmetry of the jugs and pitchers echoes not only our own bodies, but also the way we see the world. Soliz identifies her genres, or three different ways of representing the subject, as being image, space, and time: she describes her training as being conceptual and used whichever medium – film, video, painting – was most appropriate to what she wanted to say. Nothing has changed so very much then, except that her material expression has come to be worked out in clay, and that this brings with it the question of craft. She wonders how to make something slow (or laborious) look quick (or facile). How near anonymity can one get; how near individuality? These liminal pieces cross various thresholds beyond that of the public/private; for the artist they are objects with an almost talismanic quality. She wants to bring some of our more quotidian pleasures and experiences towards our assessment of her art. But if she adds the very real and everyday to our experience, she also adds something uncanny, for these objects carry their communal histories, so that the noises and movements of the past now provide them with the breath of animation. They are new, and old, oh so old.

Edited extract from the essay 'Restored to Life'.

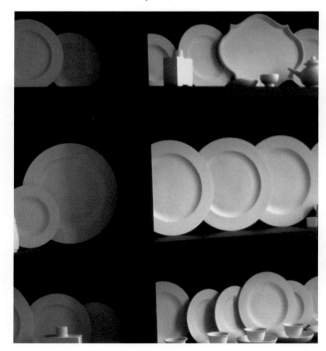

'Property of a Lady' (detail) (2002-03)

Helen Ann Jones

The artist... is a participant, a filter – the aim is to create a dialogue with the site and viewer that questions our relationship to place and time – to reflect upon that moment of discovery and understanding.

The philosophy underlying Helen Jones' artistic practice is articulated for the most part in works whose source lies in specific experiences associated with particular places or pieces of land, but which when completed embody the uncertainties of our fragile position in the world as a whole. Between the particularities in which they are rooted – the topography of an area, the pattern of its field boundaries, the traditions of a culture born of working the land – and the complexities which they ultimately express lie the artist's thoughts, methods, materials and processes. The awareness of time, change and decay which underlies their making may reside in the memory of a room or a gesture, or in the smell of bitumen, or in the pattern of a quilt. As they are worked methodically, repetitively, ritualistically, her mundane yet sensual materials themselves call up such memories of time, place, things said or felt. In doing so they open up new ideas and bid further change, until their intense materiality and richness of association imbue the finished work with its contained presence. In the ritual of their making and the spare economy of their means is borne the imprint of her upbringing on a farm in rural Denbighshire with its work ethic, its frugal sense of appropriateness to purpose, and its life intertwined with that of the chapel. Yet, rather than apparent simplicity, ambiguity, ambivalence and the all-embracingness of change inform her work. The quiet domestic space, hidden from the outside world, is intimate and contemplative but also confines. Home is the shelter which every human must have, the site of daily exchanges of love and sustenance, but it also contains, separates from the largeness of the world. Lead both preserves and harms. In Jones' work, time and materials dissolve but leave traces, as in life memories fix in time what cannot but yield to change.

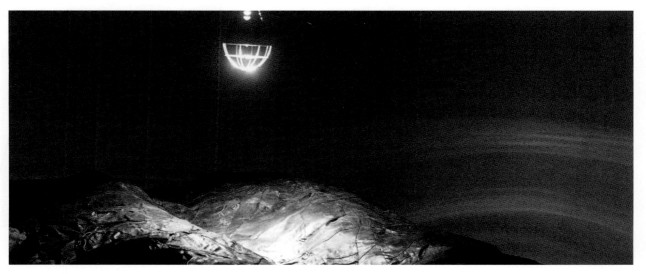

'Cartrefle' (2004) Installation of sheepskin, wax, bitumen, thread, fleeces, infra-red lamp

Martin Barlow

Corporeality

Although she considers herself principally as a painter, Yvonne Jones is currently making a considerable mark as a video artist. She is among a number of compelling practitioners exploring aspects of the human body and condition in various ways. Naturally there is a strong viscerality in the work, which would not commend itself to the squeamish. Basically it is concerned with the corporeal body and explores the sense of reality of body today, using what she refers to as "repair and maintenance" of the human body as a metaphor in medical discourse. She focuses on the surgical and medical interventions which she has experienced directly, whilst conscious, and the mediation via art of this traumatic experience.

Her work has depended on the full support of clinicians and uses materials created and collected either by them, or in conjunction with them, in various circumstances, in hospital, during operations and procedures. Material documenting the subjective experience is explored and evaluated objectively and manipulated for its presentation. She employs video, audio, photographic stills, x-rays, moulds and medical leftovers to do this.

Interestingly, we have the products of her rather forensic investigations filtered but by no means diluted, to ease their consumption. Her 'repair and maintenance' conceals the trauma of the subjective experience. This is in keeping with an approach which uses a variety of techniques initially to conceal the content by indirect method, thus enticing our curiosity and leading us further into the work. Her pieces serve to direct and determine the viewer's access to her highly personal experience and attempt to elicit reactions resulting from our more direct commerce with those aspects of our corporeal existence which are generally suppressed. She thus quite deliberately sets up an opposition to our tendency to distance ourselves from the 'realities', which is the usual effect of mediation of almost any kind. Naturally, audience response varies along a continuum which ranges from utter disgust and repugnance, to a hypnotic involvement and comprehending appreciation.

Stills from 'Memory Three – Eye of the Artist' (2004)
Video installation

Painting the Soliloquy

"Writing is a soliloquy – it's when I have conversations with myself", Christine Kinsey mused in a recent discussion about her poetry. It is therefore surprising that her work has undergone a long period of gestation before this concept was realized in paint. For years her figurative works were about being female and growing up in Wales. Yet the intrusion of the spoken word (she reads poetry aloud), is a relatively recent phenomenon; the word becomes paint. In true metaphoric style, Kinsey does not illustrate the verse literally, but interprets its essence. Although her paintings might appear to be unrelated to the poems, they are manifestations of her response to them both emotionally and intellectually and, as such, could even be described as metaphysical.

Kinsey's work is as much about the spiritual, non-physical, non-material aspects of human nature as it is of flesh, character and objects. Born into the mining communities of the Valleys, her first language English, not Welsh, female in a masculine society and a thinker in an environment dominated by manual labour, her concern is to reconcile these opposing aspects of her identity.

In her determination to learn Welsh, Kinsey was stimulated by the echoes and rhythms of cynghanedd, and subconsciously reiterated these influences in her images. Figures and motifs of remembered, if fragmented, images from childhood recur in successive paintings. These are often disguised by the context, even though the female figure – and there is always a female figure – is based on herself. Thus her paintings are autobiographical, where she adopts the persona of a diverse range of female characters who are found in Wales. In doing so, Kinsey's art speaks with a universal voice. Her resolve to subvert the norm is not related to a feminist stance, we have only to examine her feisty women and raunchy females in suggestive poses

to discover that these are portrayed with a woman's eye, not from a male perspective. Moreover, these are the same women who are alternatively modest, passive, repentant or aggressive, or who register fear or dismay in other compositions.

These concepts and the themes Kinsey articulates are reflected in her approach to the process of painting. Firstly she lays down a burnt sienna ground, then she superimposes three coats of gesso which is subsequently sanded to provide an immaculately smooth surface. Venetian red is then rubbed into the canvas and blended with turps. The architectural elements and figures are drawn in with Prussian blue, alizarin crimson and caput mortuum deep. Although thinly applied, this gives a rich density to the dark ground from which she adumbrates the figures using warm, glowing colours which are like fine, layered shafts of luminous light. Quite literally, her process illuminates the content.

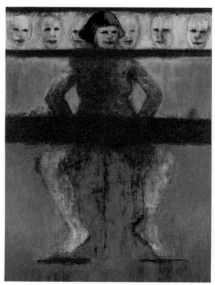

'Guardian of a Spiritual Memory III' (2000)
41 x 31cm oil on canvas

Anne Price-Owen

Elfyn Lewis offers another view, in a country to which Modernism came late and where Kyffin Williams' brand of 1950s expressionism is still regarded in some quarters as 'cutting edge'. His is for many still the acceptable, almost iconic, romanticised and timeless image of Wales, in a tradition of painting having landscape deeply embedded. The 'tourist destination' status of much of rural Wales and its function as a 'wilderness', onto which itinerant artists cast Romantic aspirations, compounded the idea of art being primarily a representation of visible nature (a painting on a wall emulating the view through a window), which in turn influenced the way art and its role in general has been viewed.

Lewis' paintings, despite their vivid colours, share some characteristics of Williams' oeuvre; they are about landscape, but equally concern the physical process of laying paint on a surface, depending too upon a degree of local knowledge to augment their imagination. Lewis' work hovers on the line between abstraction and representation, commenting on that margin and on the role of the landscape tradition in the national psyche. There are reminders of landscape in one sequence of work whilst another series moves into purely painted abstraction. The action of paint smudged between two sheets of Perspex produces discordant mirror images which are exhibited side by side.

Suspended from steel cables, these paintings remind us that the work is primarily about material processes and not merely the observation of landscape. Not windows these, but objects in themselves. Unlike the painter Brendan Burns, whose abstract paintings are preceded by drawings made from nature, Lewis' works only incidentally resemble landscape or geological forms, and sub-consciously perceived as such by the viewer. The artist encourages this process by giving his paintings titles evoking his north Wales homeland. Place names, those of local characters he knew, may grace these paintings but in no way 'illustrate' them, for painting and title are quite separate elements.

Meirion Macintyre Huws' poem 'O'r uchder hwn' in his recent collection, *Melyn*[1], lists the names of farms and villages, as a plea against forgetting. Similar themes inhabit Peter Finnemore's work. The paintings of Elfyn Lewis can be viewed simply as beautiful objects, but they are also signifiers of lost places, of vanishing characters and are another plea against forgetting.

1 Meirion MacIntyre Huws *Melyn*, Gwasg Carreg Gwalch, 2004

(left) 'Dic Ben' (right) 'Neli Wynt'
(2003) acrylic on perspex

Iwan Bala

ffotogallery

Ffotogallery is the national development agency for photography in Wales producing high quality monographs, catalogues, anthologies and artists' books.

Previous titles reflect a rich and varied range of visual arts practice including works by

IAN BREAKWELL
RUT BLEES LUXEMBURG
WILLIE DOHERTY
PETER FINNEMORE
DONIGAN CUMMING
PETER GREENAWAY
PAUL SEAWRIGHT
BEDWYR WILLIAMS

New and upcoming titles include

RAFFAELA MARINIELLO
BREDA BEBAN
RICHARD POWELL
HARRISON & WOOD

Distributed worldwide by
Cornerhouse Publications
Manchester +44 (0) 161 200 1503
www.cornerhouse.org/publications

FFOTOGALLERY, C/O CHAPTER, MARKET ROAD
CARDIFF CF5 1QE +44 (0) 29 2034 1667 www.ffotogallery.org

Image © Harrison & Wood from *The Only Other Point* 2006

Derrick Price

Re:Imaging Wales 90

Richard Page 'Exposure 8' from the series SUBURBAN EXPOSURES

Imaging Wales in the Digital Age

One of the more interesting developments of the last twenty years in Britain is that the arts have become popular with governments, local authorities and the public. In the visual arts, blockbuster exhibitions have attracted thousands of paying punters. Tate Modern is among the most visited places on the list of tourist sites; its Turner Prize gets headline publicity, and the artists it supports have become celebrities. At the corporate level, planners and property developers have transformed cities through arts-led regeneration programmes, and the creative industries are taken seriously by governments for the way in which they contribute to economic growth.

Wales, in common with other European countries, has extended the range and quality of its building-based performance arts. In the visual arts it has attracted new and innovative work into Wales by the creation of the Artes Mundi prize and exported some of the art of Wales through its involvement in the Venice Biennale. Alongside this there has been a significant growth in the number of artist-led galleries and informal spaces in which art is made and shown.

I am concerned here with only a very small part of this activity: the impact of digital technologies on art practice and photography through the emergence of new media art.

New Media Art

A definitive history of new media art may be written when it stops being new. For the moment it is not historians but taxonomists who are trying to pin down and clarify this elusive term. The convergence of images, sounds, animation, video, film and photographs into computer controlled domains has led not to a single new medium but to an array of forms. These employ technologies that are also used for many other purposes. Engineers of one kind or another are the people driving these systems, as they are in the associated fields of robotics, systems theory and bio-engineering.

It is art that, then, comes out of (and informs) digital technology – which is itself one of the interlinked forces that are radically altering almost every aspect of life in developed societies. At its heart is a complex and pervasive web of technology that is constantly changing and seeking new commercial and social uses. To be an artist in this world you need to know something about platforms, software packages, Wi-Fi, robotics, computer gaming, telematics – or, at least, work in partnership with people who do.

New media art can exist in galleries, but can also be distributed in many other forms including DVDs, internet radio, sound environments, virtual environments, CD-Roms, and even mobile phones, but it is also often intimately related to performance and live art. This interaction of art and technology is producing innovative and exciting work, but it is also having a profound effect on older forms and disciplines.

Photography

One major consequence of the coming of digital technology has been the displacing effect it has had on other art practices. Postmodern theory drew attention to the collapse of forms and genres. Baudrillard, for example, argued that signs decline to stay in their proper station as the functions of particular media, but float free, endlessly circulating and constantly being absorbed, referenced, or reproduced within an array of commercial and aesthetic forms. Bought and sold, copied, altered and transformed, these images know nothing of location, of specificity or of originality – Baudrillard's notion of the simulacrum is precisely that of a copy without an original. On this reading at least, art no longer has an archive of pure images which belong to it alone, or bodies of practice that mark it off clearly from other activities.

Of all media, photography has been most transformed by the arrival of digital technologies; not

least because the old notion that a photograph never lies can now be seen to be patently untrue. Of course, the idea never stood up to close examination. For decades we have been urged to see photographs as created objects made by particular people using specific technical forms and following certain practices or conventions. But the photographs' indexical qualities did privilege them as objects that had a special power in the accurate recording of how things look. It is this quality that the easy creation and manipulation of images using digital technology has fatally undermined.

As photography's taken-for-granted relationship to the real has broken down, its various genres have become more difficult to maintain. It is hard, nowadays, to talk about, say, 'documentary' or 'photojournalism' and feel that the terms are clear and unequivocal. This problematic status is shared by other genres within the medium.

Since the early days of conceptual art, photography has been used as a tool by artists whose primary purpose was not the production of photographs, but the realisation in a plausible medium of a set of ideas. But photography not only still exists as a separate discipline; it has found a new life for itself. We can see photography as liberated from the need to reveal how things look in the real world and able to explore quite different subjective topics. In contemporary photography few things are straightforwardly what they appear to be. The most mundane, even banal, of subjects is explored within a complex discursive frame.

Photographs are everywhere, on every page, on every screen, on every street corner, but if they are to be seen properly displayed in galleries real resources have to be found. This is not just a matter of money, but of curatorial skill, the ability to develop audiences and to contextualise work with catalogues and other materials. For this reason new photographic practice is sustained in the UK by a handful of galleries of which Ffotogallery in Cardiff is the most prominent example. In recent years it has had shows by Sian

Bonnell, Thomas Kellner, Paul Seawright, Rut Blees Luxemburg, John Davies, Bedwyr Williams, Helen Sear, Karen Ingham, Donigan Cumming and many others. Ffotogallery plays a central role in the development of Welsh visual art and the importance of key institutions cannot be overstressed. Chapter is an important space for new media work, but Oriel Mostyn, Aberystwyth Arts Centre, the Glynn Vivian Art Gallery, and Oriel Davies, together with a range of all smaller galleries, all play a vital part in the creation and dissemination of this work.

Also central to photography in Wales is the work being produced by its universities and colleges. The School of Art and Design, Cardiff is an important centre for a range of art practice. One of its projects, Cardiff Digital Portfolio One, introduced artists working in traditional media to the techniques and practices of digital imaging. In photography, both the University of Wales, Newport and the Swansea Institute of Higher Education employ distinguished artists, train aspirant photographers and provide spaces where critical debate can flourish. Newport was particularly known for its courses in documentary photography, but now covers a much wider terrain. It has estab-

Paul+a from LIFE IS PERFECT

lished a Centre for Photographic Research and is also creating a filmed archive of interviews with leading practitioners which will be digitised and made available to anyone interested in the history and practice of photography. Swansea has established a Centre for Lens Based Arts which, among other things, researches a new kind of photographic based work: photography and performance. This examines the relationship between the acts of performance and the implicit acts involved in performing photography. It provides an interesting example of the way in which new kinds of work are emerging from the displacement of genres. It is also exemplary of the kind of research work being conducted in institutions of higher education.

Universities are gradually realising that they have the power to help create stimulating and rich cultural environments. Not only do they employ a large number of artists (albeit disguising them as lecturers and professors), but it seems clear that the Arts and Humanities Research Council will become an important funding agency for the arts in Wales as well as for the rest of the UK.* What is important is that the work supported by this body is not confined to being 'research outputs' for staff, but is used to develop the whole field. The Arts Council of Wales should take the lead here, as it has to work with relatively few key institutions in higher education, and building partnerships between diverse but congruent institutions may become the most important task of national arts administrators.

The Global and the Local

Welsh new media artists and photographers play a part on the international stage, and whilst many distinguished practitioners live in Wales, it is difficult to find in their work any key to Welsh visual culture – except that it is becoming more open and international. But international art has to be located somewhere, and many of the themes currently absorbing artists across the world – the nature of identity, memory, sexuality, place – are as easy to explore in Wales as anywhere else. Nor are some of the cultural ideas that help to structure this work – dislocation, hybridity, marginality, for example – difficult to work through in a Welsh context.

What, then, is the relationship between the potential global reach of new media art and the locality in which it is made and to which it may be addressed? What, in any case, do we mean by local, national or global within the context of these technologies? A decade ago David Morley and Kevin Robbins argued that:

> We are seeing the restructuring of information and image spaces and the production of a new communications geography, characterised by global networks and an international space of information flows; by an increasing crisis in the national sphere and by new forms of regional and local activity. Our senses of space and place are all being significantly reconfigured.[1]

In one utopian vision of these technologies, power would be as dispersed as the media themselves, and would flow away from the centres of economic and political power towards the local. This was the romantic view of cyberspace: a place that is everywhere and nowhere, a global space that allows new kinds of communities of interest to flourish and might sustain local areas that are subject to depopulation. One aspect of this is the notion that we might choose to work in remote and beautiful places, but still have a networked presence in the grimy but powerful metropolitan centres. To some extent this early vision has been realised and may be increasingly so as the technology develops.

For the moment, though, cities have become more important to the development of cultural life, not less. They have the critical mass of population to be the drivers of cultural activity and consumption, but also possess the necessary technical infrastructures and, perhaps most importantly, the diverse mix of organisations and

specialists needed to form partnerships in order for this art to flourish – broadcasting companies, animation and software houses, artists, musicians, programmers, systems analysts, hackers and universities. Within Wales it comes as no surprise that the centres for work of this kind are to be found in the large urban areas of the south. Nevertheless, BT continues to promise the roll-out of broadband to rural areas of Wales and most of the country is expected to be covered in the near future. This will establish a minimum condition for effective work to take place in rural areas.

But these technologies were expected to abolish space and allow small-scale, scattered communities to flourish. Morley and Robbins draw attention to the possibility of digital technologies weakening the national sphere within the global, but strengthening the local, allowing people in formerly remote areas to be connected into viable communities – at least for certain purposes. There is considerable interest in this question in Wales and spatial problems and opportunities have been addressed in a seminar and publication by bloc: creative technology Wales.[2] bloc is the most important network in the country for artists working in digital media. A 'virtual organisation', it runs seminars and conferences, publishes and (in their own words) "investigates the theoretical and practical implications of technology on creativity".

New Media Art and its Subjects

In 2005 Big Pit, Blaenavon won the Gulbenkian Prize for Museum of the Year. It is an admirable example of the way in which museums can function to remind us of the past and the nature of community life. The tracing of older ways of life and the uses of personal and collective memory remain important features of some Welsh art. But all over the western world the feeling that our personal identity is bound up with what we do in order to make a living is fading away. Increasingly, meaning is invested not in work or community,

but in our conceptions of ourselves.

The sociologist Manuel Castells puts it thus:

> Identity is becoming the main, and sometimes the only, source of meaning in a historical period characterised by widespread destructuring of organisations, delegitimation of institutions, fading away of major social movements, and ephemeral cultural expressions. People increasingly organise their meaning not around what they do but on the basis of what they are, or believe they are.[3]

For Castells, a search for identity is at the heart of our new kinds of society. But what sort of identity are we talking about? Since postmodernism we have grown used to the notion of the de-centered subject, but more radical reappraisals of our definitions of self are integral to much new media art. One of its functions is to parley the relationships between diverse cultural forms. Informed by a whole range of theoretical positions – cybernetics, feminism, queer theory and concepts of post-colonialism – it is involved in the re-examination of the concept of 'nature' and its relationship to hybrid cultures.

The loss of a fixed, stable self is, to some extent, both a consequence of new technologies and can be extensively explored through them. The excitement of new media art is that, at its best, it takes on these central questions of our present existence and explores what kind of people we may become in future. More radically, technological convergence involves not only electronic systems but biological ones too. The idea of the automaton and the body fusing together to produce a new kind of cybernetic organism is not only the subject of serious scientific study but has become a major trope in popular culture. It is a subject frequently explored by the artist Paul Granjon (see page 34), who creates robots from a variety of common materials and uses them in performance in order to explore the relationship between new technology and human subjectivity.

On the Net

Net Art lacks the apparatus that supports the rest of the world of art; it has no patrons, no developed body of critics, no old masters, and no curatorial gatekeepers. Often immaterial and rarely archived, it exists as a networked stream of images, sounds and sensations. Networks are at the heart of the technological paradigm that structures digital production – not least because interlinked computers are a pre-requisite of the system. These networks have often been seen in utopian terms as providing the means for ordinary people to join together and challenge the hegemonic power of governments or big business. They are often described as 'bottom up' systems which are open, flexible and democratic. Rather more dystopian accounts of networks have been offered, but they remain at the heart of things and need to be extensively explored. In 2002 Simon Pope curated a fascinating exhibition, ART FOR NETWORKS, at Chapter. A dozen artists investigated and critiqued those networks (widely defined) that were essential to their work.

It is obviously important that Net Art can be accessed in many environments and that it exists outside the world of the gallery. But, when they have found it, what does digital art offer the spectator? For some people the technology appears as a kind of elaborate box which when broken into contains nothing but a trumpery toy. Yes, yes, all very interesting, but what about the content? When one has done clicking, or surfing, or whatever, where's the real payoff? The fact that much of the technology emerged from the gaming industry has been one factor in the creation of many playful environments. Complex play can be seen as an imaginative way of structuring creative ideas, but may also be viewed as tediously facile. We might, however, argue that the very notion of content in this context is absurd. This is an art which constructs us as users rather than spectators; users who are required to be involved in working through its often open-ended and discontinuous narratives.

But before we can engage with this work in any creative way we have to be able to find it, use it, appreciate it, critique it, and this does call for a range of facilities to be available.

Making Things Happen

In a study of the provision of facilities for new media and the visual arts in Wales undertaken in 2003, Dr Justin Marshall argued that:

> The geography of Wales naturally created dispersed communities, but the low level of response from users indicates that artists are especially isolated; there is a need to co-ordinate activities and resources to meet users needs and maintain a network of artists working with new media... As yet, the virtual properties of new media are not being harnessed.[4]

Marshall noted that new media art is an "ill defined constituency" and drew attention to the lack of training opportunities. He also observed that there is no venue dedicated to new media work and few critical events for this sector. In order to stimulate work of a high quality he suggested that "there is a need for new opportunities in the initiation, production and presentation of work through a new commissioning body." One response to the survey was the creation of a festival of creative technology held in Cardiff in October 2005 under the title MAY YOU LIVE IN INTERESTING TIMES. Developed by Emma Posey of bloc and Hannah Firth of Chapter, it provided an exciting mix of seminars, performances and exhibitions which covered a range of new media work. There was a chance to see work by Blast Theory, Michelle Teran, Andy Fung, Nina Pope and Karen Guthrie, among many others, whilst Tim Davies' work 'Drumming' was shown to wonderful effect on the digital screens of the Millennium Stadium. It also supported residency programmes in Cardiff (Grennan & Sperando), Cardigan (Jen Hamilton

and Jen Southern) and Bangor (Scanner); the latter two being managed by Cywaith Cymru/Artworks Wales. This event provides a new impetus for new media work which, if built upon, can radically improve the opportunities for artists and audiences throughout Wales.

Festivals of this kind have been essential to the development of new media art. More problematic is how far it should seek to be represented in gallery settings. On the one hand this would allow it to take its place alongside other forms of art, but it is also possible to argue that its present power and interest derives from its de-institutionalised status. Discussing video, Julian Stallabrass has argued that it only became fully accepted within the art world when it moved onto a big screen as video installation. In this way it gained a gallery audience that understood its conventions and learned its rules, but it lost its critical relationship to the dominant medium of television[5]. This is an interesting point, but it seems unlikely that new media art could ever be confined to the gallery. The history of contemporary art may end up being written as a history of screens – from movies to the mobile phone via television and video. One kind of screen is very different from another and they construct us as spectators and users in multiple ways, but so long as they are ubiquitous new media art is likely to be found in many diverse settings.

In this short piece I have tried to look at some of the features of photographic and new media art practice within a Welsh context. Clearly, it has not been possible to present a nuanced account of the range of work that is on offer, nor do justice to the artists and organisations that have made it happen. Future editions of *Re-Imaging Wales* will no doubt include many of them in its profile pages.

* The Higher Education Funding Council (for England) recently ran a day seminar and workshops on performance related practice and means of accessing appropriate grant-aid, which could do with replication in Wales (ed)

References

1 David Morley and Kevin Robins, *Spaces of Identity*, Routledge, 1995.

2 Emma Posey (ed) *Remote: Essays on Creativity, Technology and Remoteness*, Bloc Press, 2003

3 Manuel Castells, *The Rise of the Network Society*, Blackwells, 1996

4 Justin Marshall, *A Survey of Provision of New Media and the Visual Arts in Wales*, A report commissioned by bloc and Chapter, 2003

5 Julian Stallabrass, *Internet Art: The Online Clash of Culture and Commerce*, Tate Publishing, 2003

Invitation to MAY YOU LIVE IN INTERESTING TIMES featuring Tim Davies 'Drumming'

Homeland Dreamland

It is extraordinarily difficult to categorise Sally Moore's work. Clearly it represents one facet of the substantial and catholic practice which is Welsh painting and clearly she is heir, her present residence in London notwithstanding, to a native tradition of narrative painting and myth-making which is both universal and, in her case, highly personal. The meticulousness with which she depicts her subjects is Pre-Raphaelite in its intensity and might even be characterised as obsessive. Her almost invariable use of herself as subject (or, possibly, model for the subjects) in her work also seems obsessive and brings further intensity and an electric, almost neurotic, quality, so that we are forced to regard the paintings as being on the cusp of Surrealism, or even Metaphysical art. Her use of objects and the discrepancies of scale reinforces this and her tendency to depict herself peering through an array of objects, facing towards, but neither regarding nor betraying an awareness of the viewer, contributes to the Through the Looking Glass quality of a significant number of the paintings. That she has a penchant for certain categories of object is obvious, though rarely does she paint still-lifes, simply depicting them. There is generally a disturbed (and disturbing) human presence, all the more so for it being her own. The paintings frequently seem to possess a particular and peculiar patination, although this resides more in the scene depicted than in her technique. Her works' Pre-Raphaelite atmosphere is further compounded by the presence of huge numbers of objects cluttered, rather claustrophobically; there always seems to be something of ectoplasm, or at least a Victorian mist, lurking in her rooms, which goes well with the atmosphere of underlying threat. None of this is to suggest 'mere' nostalgia, or a species of academic derrière-guardism; her painting is immensely strong, highly complex and she sits interestingly as a rich (and yet another

aberrant) talent, among the substantial cohort of highly differentiated 'dreamer painters' in Wales.

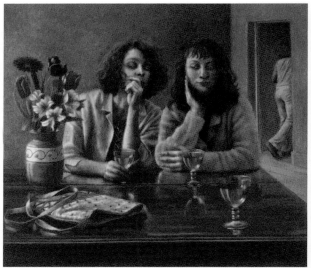

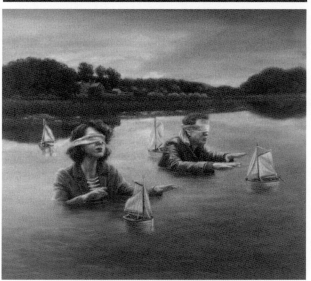

(top) 'Reunion' (2004) oil on panel 43 x 49cm
(bottom) 'Search Party' (2004) oil on panel 55 x 62cm
(courtesy Martin Tinney Gallery)

Mike Organ

Mike Organ is one a number of artists whose dedication to their own work has been circumscribed by a lifelong commitment to art education and the sharing of creative skills with younger generations. As Head of Design for many years at Fairwater Comprehensive in Cwmbran and in other capacities, he has made many distinguished contributions to art education. These have been as an adviser to 141 secondary schools, examiner, consultant and writer in the Higher Education sectors. His activities have provided an important and generous grounding for many who have subsequently chosen the visual arts route for their careers.

Mike Organ's complex and detailed work draws on multiple sources of imagery and media, and embraces diversity as a positive element in his work. This can and does include such disparate sources as memory, the mass media, Outsider and Folk Art, the natural environment, the inspiration derived from working directly with the fertile imaginations of young people, and much more besides.

It is also the case that Mike sees the working process itself as being at least as important as the finished work. Like many of us, for him it's the journey that counts. The end results can be – to use his own words – "agreeably ambiguous, unpredictable and open to the kind of association and interpretation given by others". These results are hard won and completed works represent countless hours of dedicated activity engaging in several different and demanding media.

The work that evolved over an extended period was the subject of a major retrospective at Newport Museum and Art Gallery in 2004. The characteristic energy and enthusiasm indicative of his enduring sense of enquiry can be traced through the intricate and obsessive detail of his many constructions, painting and prints. Mike Organ is one of those prolific artists who can, and often does, "do six impossible things before breakfast", to misquote Lewis Carroll.

'Punk – wire in the blood' (detail)

Richard Cox

Suburban Exposures

I have encountered SUBURBAN EXPOSURES many times since its conception in 2003. On each occasion the changing contexts in which I have viewed the work has inspired a more surprising and thought-provoking critique and appreciation. Its intention to explore the "psychological spaces on the edge of suburbia" is clearly successful, yet what is key to this success is that it has to work directly with the psyche of the viewer. I am struck by the reference to family ideals and the notion of home. As imagery of the private within the family are becoming increasingly exposed in the public arena, SUBURBAN EXPOSURES is subject to more raw and telling narratives of family life. Page further compounds these ideas through his use of surveillance, fantasy, artificiality and reconstruction in landscapes and spaces that are deliberately distorted through technique and process. The underlying sense of unease, driven by what is lurking 'behind closed doors', further exemplifies the shattering of the family myth.

Page looks to suburban spaces as the subject for these haunting and unsettling images. Each image presents a distant view of idyllic family streets and homes that, when shot in more conventional ways, may simply comment on suburban family life, or work as social documentary images. These images are carefully constructed and presented as beautiful light boxes, luminescent and saturated with colour. They are framed by blurred edges that point toward an almost model-like scene, suggesting that they are to remain within a fictitious context. They are removed from reality, allowing the viewer to be more adventurous with their own narratives. They explore the concept that the home is no longer a place of security and privacy, but a penetrable space, at risk of invasion both externally and, more sinisterly, internally. Drawing on the rhetoric of the suspense present within the horror movie and allegorical expressions

(top) 'Exposure 4' (bottom) 'Exposure 1'

these images launch the viewer into a narrative that is implied, resisting a resolution.

SUBURBAN EXPOSURES speaks to everyone; the series has a breathtaking impact that allows the most novice of viewers to be drawn into them. They force us to question the safety of the suburban space and our understanding of family ideology. They are deeply troubling and thought provoking yet explode with great aesthetic beauty.

Francesca Genovese

Kissing or Killing?

He lets me see only one image. A man and woman tumble out of shot at the foot of a bed. It is enigmatic, uncanny and deeply troubling. It emerges not from a world of cheap pornography, of calculated violence casually achieved behind closed doors, but from the world of shadows caught out of the corner of the eye. This image from 4.00am is an image of 4.00am, of nightmare. Perhaps his notion of performance photography restores lost time to his medium – as he earnestly desires – as dream-time. Here as he says, "the act and its record are collapsed into one", combined as a single utterance. There was no live audience; the only witness was the camera standing in the corner, the shutter released at the moment of greatest passion, of death, by the protagonist. 50 love scenes, each ending in a murder, prepared, enacted and recorded over 24 hours in a hotel room. And he lets me see only one image; takes my photograph looking at it. What I look at with awe – with amazement and dread – results from a practice deeply theoretically informed, in a project rigorous in concept and execution. Performance and photography take up a new relationship; this he uniquely conspires.

Paul Jeff & Sara Dowling; the artist works as Paul+a and in collaboration with different female artists on a project-by-project basis. The work illustrated is called LIFE IS PERFECT: DARK INSTANT and refers to the biblical text:

> But Jael, Heber's wife, picked up a tent peg and a hammer and went quietly to him while he lay fast asleep, exhausted. She drove the peg through his temple into the ground, and he died.
>
> (Judges IV. v. 21).

from LIFE IS PERFECT

Mike Pearson

Richard Powell

Modernism changed the making of art in many ways but failed to change the world and art's place in the world in the ways that it set out to do. Its promises have yet to be kept. The belief that they never will be kept, the realisation of this tragic defeat (Yeats) and the concomitant need to somehow still go on (Beckett) lies feeding on regret at the heart of what we have learned to call the postmodern.

Contemporary artists have the ability – some say obligation – to attend to this unfinished business... these promises invoke how art and artists relate to their audiences, how one art relates to another and how a work of art's own inner workings, its interior dialogue, takes place in its making. This last remains the basic promise, the one on which the others' chance of success rests.... The promises that were made concerning the inner integrity of a work of art involve balancing concerns for literal-visual representation with those for design, materials and media so that no one concern can enslave the other, and each has the chance to be itself and contribute to the whole. This means that the design elements such as texture, colour, structure and composition become and remain as full and equal expressive forces in the work.

I invite the reader to consider how these sketchy ideas relate to Powell's work, when it can be met with on a direct, first-hand basis. I have found that his work tends to keep deep faith with these promises. Out of his rigorously disciplined decisions about how materials, media and design interrelate and serve and survive, without diminishment, the demands of representation comes an especially successful and expressive force. It enhances the literal-visual by denying it the role of a bully and by transforming it into a partnership that strengthens and unifies expression.

Idiosyncratic ideas and objects animate Powell's thoughts and feelings and how he talks about his work. Literal-visual references to the world undergo severe metamorphosis. For all its vigour and ambition, contemporary art rarely comes up with work like this, that so comprehensively fulfils the potential that continues to be our common legacy. May the reader and audience take full measure of joy in how Powell pays that legacy homage.

(top) Installation, artist's studio, residency IMMA. Dublin (1998)
(bottom) Remains of 'Quarry' (2000) red deer glitter box

Paul M O'Reilly

Jennie Savage

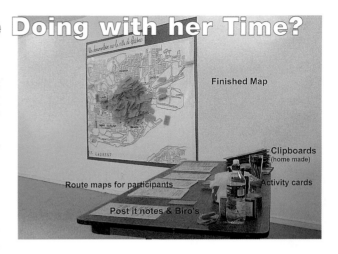

Finished Map

Clipboards
(home made)

Route maps for participants

Activity cards

Post it notes & Biro's

Being a re-historian. Standing at the intersection of place and perception asking questions about history in present time. And getting clear about how far she as artist/interventionist can uncover the answers without implicating herself in the process. Because any fixed position would imply an agenda, social, political, cultural or otherwise; and she's not out to make a point but to observe them and above all to remain level with the participants in her work. So we see her intervene and then playfully back-step by using ideas of randomness and chance narrative to openly relate that whilst maps, collections, archives and indexes do exist, navigation is still individual.

For Jennie, history is made up of an event, a witness and a record of both – followed by an endless cultural re-presentation and re-witnessing by a contemporary audience. How we record history isn't really the question, although in Scarchive she debunks the idea of traditional mechanics by exposing the body as a way of recording history. Really it is the witness that plays the most central role in her work even when absent. She overtly suggests that perception is a cultural construct impacted by place and that we are constantly being asked to view history from a prescriptive standpoint. It is a mono-view her work rejects. It is a door she wants left open.

After all, if history is made it can be un-made and re-made – along with our perception of it.

As artistic practice it's also a radical reworking of the concern with the witness as critic, where instead the witness is now subject, as art and audience become synonymous. And what passes for history is of our own making. With a little help from Jen.

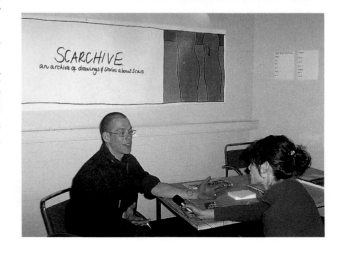

SCARCHIVE
an archive of drawings & stories about scars

(top) 'Documentaire sur la Ville de Québec'
Trace exchange, (Québec 2004)
(centre) 'Anecdotal city bus tour' Anecdotal city project (2002-03)
(bottom) 'Scarchive: an archive of stories and drawings
about scars' (Chapter 2004)

Bay Baker

Bedwyr Williams

Bedwyr Williams bases his stand-up comedy routines, performances and writing on stories he just cannot get out of his head, from hitting golf balls through electric Welsh harps to florists making wreaths based on a singer's lips. They have a satisfying mixture of sentimentality and satire whose sting lies in their tackling of such unfinished business as dealing with childhood adversaries and other issues the rest of us might choose to leave well alone.

Living and working in Caernarfon, north Wales, Bedwyr is a recipient of the Paul Hamlyn Award and represented Wales at the 51st Venice Biennale, his residency there documented by a series of posters and *Basta*, a hilarious publication of photographs and texts. Williams began doing stand-up comedy at evenings arranged by friends. His Grim Reaper character came from a period in his life when every weekend seemed to be caught up in a violent incident and dressing up in a reaper-robe to read thirty points about violence became a kind of therapy. More recently many of his performances have been made at the invitation of other artists to participate in their projects, such as at Juneau Projects with MOTHERFUCKING NATURE, or Emily Wardill's FEAST AGAINST NATURE. Others have been during group shows, such as ANGLO PONCE in Brixton, or ROADSHOW, organised by Grizedale Arts.

The funny side of Bedwyr's work is a thin veil for addressing the politics of identity and place, though he rallies against nationalism and essentialism, preferring to work frontiers within his own constituency. Being bilingual is key, but he's no 'chest beater', speaking Welsh as a first language in life and not to make a point. In many ways Williams is guarded about his role as antagonist and tends to shun confrontation for a more cerebral approach. Maybe Williams' success is partly down to the fact that people on the whole like to be entertained, though he counters this by pointing out that there seem to be so many disapproving serious faces in his audiences, speculating that "they're probably reading this now, still scowling".

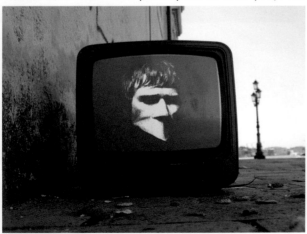

'Basta' (Venice Biennale 2005)

'Pebble Dash' (2003)

Bruce Haines

Replacing the 'I'

Karla Williams is an artist whose practice has included painting, sculpture and installation but whose most recent and perhaps most powerful work has been in lens-based media. Williams' work is strongly informed by responses to a range of issues, issues often very close to personal experiences and histories of Williams herself. But her work transgresses the level of personal narrative, replacing the 'I' of the subject with the 'eye' of the lens. The viewer is placed in an intentionally uncomfortable position of viewing glimpses of very private and often traumatic scenes in the light of an open and supposedly public space. Abortion, eating disorders, domestic violence and elder abuse are all subjects dealt with in Williams' work, although her approach is always one of subtlety and humanity rather than prescription or confrontation.

Narrative is a device central to Williams' images, in recent works such as UNTITLED (2003) – two very small close-ups of a silver dinner fork and brass 'engaged' toilet sign – and ANTI-CHAMBERS (2004) – a series of five 60-second vignettes of empty hallways, hinting at 'out-of-shot' domestic abuse in the shattering of a dinner plate, or the still-spinning wheel of an upturned wheel chair. These fictionalised realities reverberate with unspoken truths which we can all imagine and at times identify with. VANITAS DELICTI (2003) is a stunning, seductive and yet brutal series of photographic still-lifes of instruments for the making (and maintaining) of the perfect female body-image: colonic irrigation tubes, hair waxing strips, surgical chisels, diet pills and cocaine.

The aesthetics of the Williams' images serve not to lighten the subject at hand, but to frame and contain that which is essentially uncontainable. But therein lies their strength; in the power of the eye (and indeed the 'I') that chooses to probe the overwhelming, whose lens goes into the organs of the social body – into the home, the family, places of privacy, solitude and secrets – to reveal the physical workings that underpin it and the pain that it can sometimes conceal.

From VANITAS DELICTI (2003) Series of six medium format colour photographs

From PURGE (2002) Series of three 35mm colour photographs

Paul Hurley

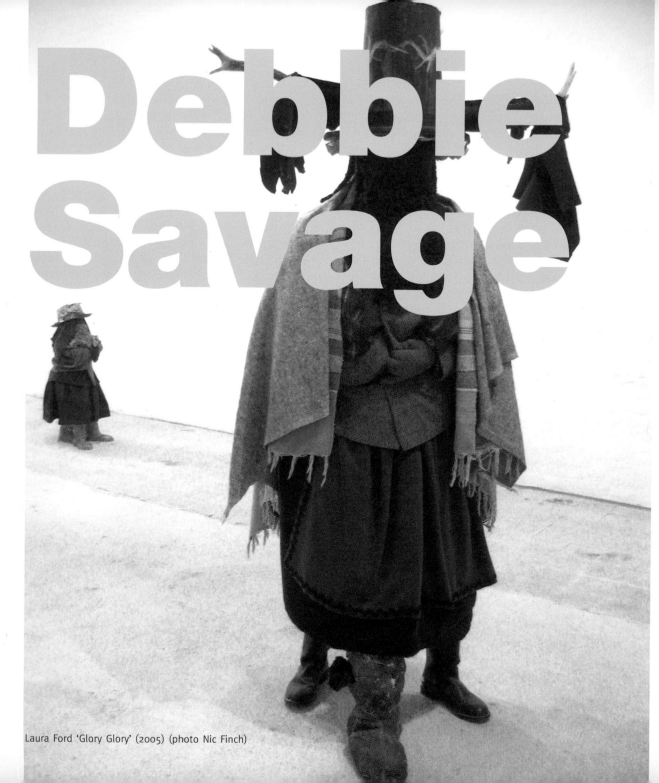

Debbie Savage

Laura Ford 'Glory Glory' (2005) (photo Nic Finch)

Some-where Else: Wales in Venice

The Venice Biennale is undoubtedly one of the major events in the arts calendar and the latest 51st Biennale has, on the face of it, been widely accepted as a success by art critics and audiences. With its 73 official shows, it is hard to disagree with Michael Nixon, the commissioner of the Welsh Pavilion, that: "the Venice Biennale of Art is the show that every artist wants to be in and every nation wants to be at"[1].

Although this statement is, in many senses, true, it does little to describe the nature of the Biennale, which on the one hand is a celebration of contemporary art, on the other, a sycophantic celebration of the art market. Compounding the confusion is the fact that the Biennale operates as the 'Vatican' of the art world, with its own version of democracy, presenting a distorted view of today's political and economical realities. Less than 30 of the official exhibits are located within the Giardini, the main exhibition site; the rest, including Wales, Scotland and Northern Ireland, form what are termed 'Collateral Exhibitions', or a selection of 'sanctioned fringe events'[2]. For the 'devolved nations' of the UK, this is because "in the arcane language of the Biennale"[3], they are not considered by the administration to be 'nation states'. Similarly, the dated hierarchical arrangement of the pavilions of the Giardini demonstrates the difficulties experienced in adjusting to the modern world (and, as the Guerrilla Girls constantly reminded visitors: "where are all the women artists of Venice?") for, although the Biennale purports to be a festival at which the countries of the world exhibit on an international platform, its attitude to national representation denies many global developments of the past fifty years. Various countries' responses to these odd constraints seem to reflect their motivations for exhibiting in the first place, as representation of the UK nations neatly illustrates.

Great Britain has been exhibiting at the Venice Biennale since 1909 and is one of the few countries having pavilions on the main site. Its 2005 exhibition is a Gilbert & George solo show, the second time the pair have represented Britain. Titled GINKGO PICTURES, images of leaves – from Ginkgo Biloba trees – are combined with Arabic motifs, faux 'G&G' designer labels, figures of youths in hoodies, and G&G themselves, in a characteristic stained glass like grid of twenty-five pictures. Regardless of the intrinsic worth of the works, the celebrity of Gilbert & George can be guaranteed to draw a large audience and critical interest. Ironically their selection reinforces a colonial attitude, which indicates the dominance by Great Britain over the wider art world and suggests that there are no more than a rare handful of metropolitan gallery artists able to represent the rest of the UK. The presence of a 'fringe' pavilion from Artsway, the Hampshire gallery, emphasises that there is more than just a Celtic dissatisfaction at the British Council's choice.

Wales, Scotland and Northern Ireland have, in contrast, produced mixed exhibitions, each showing the work of artists who have previously exhibited on the international stage and are on the verge of a new phase in their careers. The 51st Biennale is the second for Wales and Scotland and the first for Northern Ireland and provides an important showcase for the work taking place within each nation.

Wales' first representation was met with critical acclaim. FURTHER, curated by Patricia Flemming and featuring the work of Cerith Wyn Evans, Bethan Huws, Simon Pope and Paul Seawright, established Wales as a worthy contender in the contemporary art field. That exhibition had its critics, who argued that a Scottish curator and artists from, or living, elsewhere were unable to truly represent Welsh art. SOMEWHERE ELSE, the current exhibition, although addressing some of these issues, is still dogged with the same criticisms. For example, Sir Kyffin Williams was reported in *The Times* as arguing that Wales in Venice has "got into the hands of people who know nothing about Welsh art. They just put in

any old person. It angers the Welsh people. It's absolutely ludicrous"[4]. The BBC 'Onshow Forum' also contained such comments as "are these artists really representative of Wales?"[5]

Clearly these comments are problematic as they assume that Welsh art is easily defined and quantifiable. As this publication shows, this is an assertion that is inaccurate and incredibly reductionist. Instead, curator Karen MacKinnon chose to present a snapshot of contemporary art in Wales, by artists who engage with international debates in unique ways; as Iwan Bala suggests, "the aim for Wales should be to be different, not to follow the example of others, but to have fun with its own idiosyncrasies".[6]

Wales' idiosyncrasies certainly shine through in Somewhere Else. MacKinnon draws on Mikhail Bahktin's theory of the 'Carnivalesque', which sees laughter as a subversive force, using sensationalism and hyperbole to mock hierarchies and allow for alienated voices to be heard; this chimes well with Wales' position in the Collateral Exhibitions. The sound of disruptive laughter also forms a common thread through the exhibition, producing a sense of cohesion without forcing a strict curatorial view or narrative. Peter Finnemore's three video installations form an amalgamation of cultural signifiers that permeate our mediated world. With an enormous sense of play, Elvis impressions and cowboy showdowns point at a re-mapping of the western world and create a salad bowl[7] of cultural identities. Finnemore's constantly camouflaged state, along with pieces like Basecamp, where a camouflaged and ominously smoking garden shed eventually opens to reveal a disco ball, also serve as a constant reminder of the ease of misdirection, the frivolity of a nation at war watching reality television.

Like Finnemore, Laura Ford also disguises the politics of her work beneath comical, ambiguous and terrifying figures that draw on childlike responses to the unknown. Her work Glory Glory is a collection of humanoid characters in a mishmash suggestion of national costume, assembled through remembered stereotypes, influenced by current fears of war and inhumanity. These figures are accompanied by 'The Beast'; half-human, half-cat, it adopts a tired and broken pose, slouched and alone. Unlike the other hooded and mutated figures that appear throughout the Biennale, and which tap into images of war and torture, Glory Glory and 'The Beast' connect on a deeper psychological level, mixing adult concerns with childhood 'monsters in the closet'. The artist's use

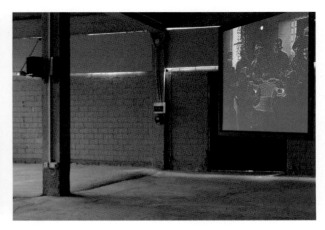

Peter Finnemore 'Basecamp' (2005) (image Polly Braden)

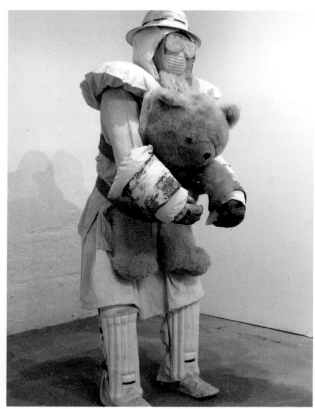

Laura Ford 'The Beast' and 'Glory Glory' (2005) (photos Nic Finch)

of masks and other objects to create/hide the face of her figures, gives them their ambiguous human-like quality, but also the sense that something so terrifying and empty lies beneath these masks that it has to remain hidden.

In contrast, Paul Granjon tears down the fabric of culture and 'civilisation' to reveal the fundamental principles of nature's programming. His installation THE ROBOTARIUM is an artificial habitat enclosing three robots, to live as their programming dictates. The audience is invited to watch male and female robots move around the arena, using sound and light sensors to find their way. At 'random' intervals they reach the 'in heat' loop – their main priority, both partners willing, to engage in sexual intercourse. The excitement and involvement of watching the robots hunt for a mate is sharply defused by the voyeuristic nature of watching the simulated intercourse.

The third robot, Smartbot, is small and oval, with long eyelashes and big blue eyes. Moving around its pen, Smartbot reacts to obstacles by swearing in English and French, before entering the centre of the space to cry. Whereas the sexed robots' only aim is to mate, Smartbot's only purpose is to be angry, lost, and depressed. Through the veil of science and the 'neutrality' of computer programming, Granjon is able to provide a vivid commentary on the relationship between technology and the modern world, as well as the relationship of the modern world to nature; in THE ROBOTARIUM, these binary oppositions are united.

Exhibiting as the joint Wales at Venice / Cywaith Cymru 'artist-in-residence'/ was Bedwyr Williams. His work BASTA (Enough) was inspired by the experience of living and working in Venice over a fourteen-week period. His work appeared in two parts: a collection of large Photoshop posters linking Venice and Wales and a book of images and text. Unlike the work of the other artists, BASTA is completed on the streets of Venice itself, with grumpy shop-workers and the small dogs of the city providing a Bedwyr Williams-eye view of the city:

> After I found out I was coming to Venice a lot of older men told me about their time in the city as young men. I was given suggestions for things I could do whilst living there... It would have been more useful if they had told me where not to go.[8]

Like a true outsider, Williams continually draws comparisons between Venice and his home in north Wales; each is viewed in the same dry and deadpan way, drawing attention to the anomalies of life and the idiosyncrasies of its systems.

Also taking place as a Collateral Event was REACTION, an international performance event using public spaces as performance sites. Eddie Ladd, Marc Rees and André Stitt showed work within this context, highlighting another facet of contemporary art practice in Wales, that of performance art. Ladd's performance of 'Sawn-Off Scarface' re-enacted the final actions and stage directions of 'Scarface'; Rees' 'Adagietto ar Deg' drew its inspiration from *Death in Venice*; and Stitt's 'Ti Amo' continued his I LOVE YOU series, handing out badges and telling the crowd "I love you". These pieces were played out initially in the Campo Santo Stefano, and later repeated at the Piazzale Candiani in Mestre. This kind of unquantifiable action, as with the ephemeral nature of performance art, stood in stark contrast to the more corporate side of the Biennale. REACTION not only presented art directly to the passers-by of Venice, but also provided a fleeting reminder of

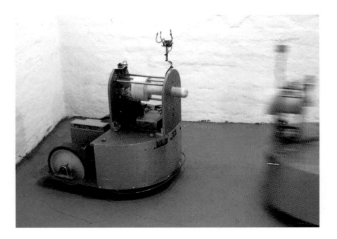

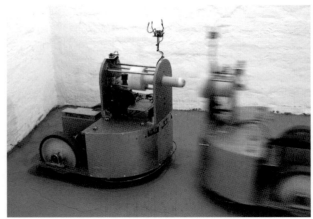

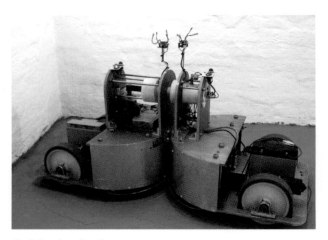

Paul Granjon, THE ROBOTARIUM

one of the main focuses of the Venice Biennale, an international celebration of contemporary art practice.

Although the collection of work being shown by Welsh artists in Venice does not represent the art world of Wales as a whole, it is an example of the diversity and quality of work being made. The overall effect is to create the "boldness"[9] of an art scene carving its own path into the international art world. The success of Wales at the Venice Biennale is redundant however, if support is not provided at a grassroots level, by maintaining the infrastructure that produces artists of an international calibre. As Gordon Dalton suggests, "if we were not there [at the Venice Biennale] it would show a lack of ambition" but "the infrastructure in Wales needs to be supported. If we are promoting ourselves overseas it should not be to the detriment of what goes on here."[10] Recent murmurings about the assimilation of the functions of the Arts Council of Wales by the Welsh Assembly and the structural changes to the creative industries that are currently taking place show that there is a real risk that everyday support could be ignored in favour of prestigious, headline-grabbing events like the Venice Biennale. One thing history should have taught Wales by now is that it is equally important to be inward looking as it is to show the world what it is capable of.

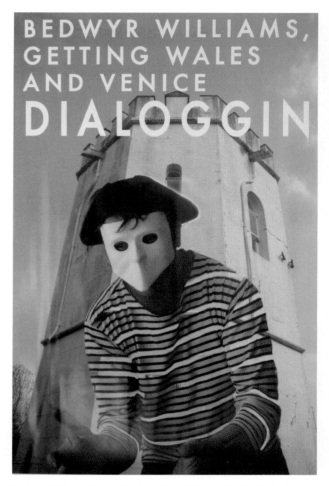

Bedwyr Williams BASTA Posters (2005) (image Polly Braden)

Notes

1 Michael Nixon, *Somewhere Else*, Wales at Venice catalogue, 2005

2 Iwan Bala, Wales Art World, www.walesvenicebiennale.co.uk

3 Michael Nixon, *Somewhere Else*, Wales at Venice catalogue, 2005

4 'Welsh Artists make way for French Robots', *The Times*, June 10th 2005

5 Pete Rhondda, www.bbc.co.uk/onshow/onlocation/pages/ venicebiennale_04.shtml, 25th June 2005

6 Iwan Bala, Wales Art World, www.walesvenicebiennale.co.uk

7 Carl N Degler, *Out of Our Past: The Forces that Shaped Modern America*, 1970 – in reference to the multicultural nature of America.

8 Bedwyr Williams, BASTA, 2005

9 Iwan Bala, Wales Art World, www.walesvenicebiennale.co.uk

10 'Shouting out to the World', *Western Mail*, January 18th 2005

Notes on contributors

General Editor Hugh Adams wrote *Imaging Wales: Contemporary Art in Context* (Seren/Wales Arts International, 2003), this publication's predecessor. He has written extensively on visual arts and cultural matters since the publication, in *Studio International*, of his 'Against a Definitive Statement on British Performance Art', which coincided with his directing *The Performance Show* in 1976. Since he written for many publications, including *Artforum, Flash Art/Heute Kust, The Guardian, Art Monthly* and *AN*. He is editorial assessor for *Cuarto Oscuro*, a Spanish photographic series. Britain's first university 'art-critic-in residence', he was Director of Critical and Theoretical Studies at Humberside University and has taught Arts and Cultural Management at Oxford Brookes and Sussex Universities. He was first Director of Oriel Mostyn and until recently a member of the arts commissioning advisory group for the National Assembly building, a member of the management committee of Wales in Venice and Chair of Cywaith Cymru.

Guest Editorial writer Iwan Bala is well-known as an artist and critical commentator. He has exhibited and published extensively in Wales. His *Certain Welsh Artists: Custodial Aesthetics in Contemporary Welsh Art* (Seren, 1999) and the catalogue *Offerings + Re-inventions* (Seren & Oriel 31, 2000), which coincided with the (then) Oriel 31 exhibition of the same title, have been fundamental contributions to establishing critical orientations and enabling informed discourse concerning contemporary Welsh art. Currently he is Special Projects Manager at Cywaith Cymru and has edited *Groundbreaking* (Seren, 2005) celebrating the organisation's 25th anniversary.

Dr Derrick Price is a freelance writer and researcher who has written extensively on photography and visual culture. His publications include *Koudelka – Reconnaissance – Wales* (Ffotogallery et al. 1998) and a seminal contributions (Thinking About Photography: Debates, Historically and Now) to *Photography: a Critical Introduction* (ed. Liz Wells, Routledge, 2004). Formerly associate Dean of the Faculty of Art, Media and Design at the University of the West of England, he worked for many years in higher education and is now a Visiting Research Fellow at the University of Plymouth and a Business Fellow at the University of Exeter. He is a founder member of the photography group New Cut Projects, chairs the Council of Management of the Watershed Media Centre and is a Board member of Cywaith Cymru.Artworks Wales.

Debbie Savage is a freelance writer who has been writing about contemporary art in Wales since she moved to Cardiff in 2001. She regularly writes reviews and features for magazines and newspapers, with a particular focus on performance and live art and has worked closely with a number of artists and independent galleries. She also has an interest in how the arts are represented and debated in the mainstream media.

Martin Barlow is the Director of Oriel Mostyn, Llandudno and has been a member of the management committee of Wales at Venice for the past two Biennale.

Bay Baker studied socio-linguistics and works in web-based communication.

Dr Jon Bird is a Research Fellow in Creative Robotics at the University of Sussex. He co-founded Blip, a Brighton-based arts-science forum.

Guy Brett published *Carnival of Perception: Selected Writings on Art* (inIVA, London, 2004). His has been a distinctive independent voice in

art criticism since the 1960s, He has been particularly instrumental in making the work of Latin American artists known to a wide public.

David Briers is a writer and freelance arts consultant.

Dr Jonathan Clarkson lectures in the History and Theory of Art at Cardiff School of Art and Design, UWIC. He has published essays on contemporary photography, painting and sculpture, and has recently finished a book on John Constable to be published shortly.

Christopher Coppock is Director of Ffotogallery in Wales whose extensive experience of exhibition curation is underpinned by a keen interest in cultural politics; he has 25 years experience of editing and publishing high quality catalogues, monographs and artists' books.

Richard Cox is a well-exhibited artist. His exhibition UNFINISHED BUSINESS (see book review section) was at Newport Museum and Art Gallery in early 2005. Currently he is Director of the Howard Gardens Gallery, Cardiff.

Penelope Curtis is Curator of the Henry Moore Institute, Leeds and first showed Cecile Johnson Soliz's work in PRIVATE VIEW at the Bowes Museum, Barnard Castle in 1996.

Prof Tony Curtis is Professor of Poetry at the University of Glamorgan and a prolific writer on art in Wales. He is author of *Welsh Painters Talking* and *Welsh Artists Talking* and his essay on Peter Prendergast, 'The Spirit of the Paint', was recently published in *The Painter's Quarry*.

Carole-Ann Davies is Chief Executive of the Design Commission for Wales and was formerly Director of CBAT.

Oliver Fairclough has been Keeper of Art at the National Museum Wales since 1998 and is currently working on a phased redisplay, from 2007, of the national collection which will cover the art of Wales since 1945 in greater depth.

Peter Finnemore was one of Wales' artists at the 2005 Venice Biennale of Art. His profile appeared in *Imaging Wales*. Since then he has exhibited widely. His ZEN GARDNER, a Mostyn Gallery exhibition, toured widely with an excellent accompanying catalogue (2004); Ffotogallery's *Gwendraeth House* (2000), is another excellent reference source for this artist.

Steve Freer was cinema programmer at Chapter, Cardiff and has written extensively about film and television. He is now a television producer, specialising in programmes about the arts.

Francesca Genovese is a lecturer, writer and photographic artist. Her work deals with issues of the self-portrait, family and memory. She is Curriculum Manager for Photography at Havering College.

Sara Gillett is a curator and exhibitions officer in the Visual Arts Department of the British Council in London.

Bruce Haines is a curator and writer who worked at Oriel Mostyn and CVA, Cardiff where he organised UNCONVENTION with Turner Prize winner Jeremy Deller. He is presently Exhibition Organiser at Camden Arts Centre and co-ordinator of FOLK ARCHIVE: CONTEMPORARY POPULAR ART FROM THE UK, which toured to Aberystwyth Arts Centre in 2006.

Anthony Howell is an artist, much-published writer and poet. He was Editor of *Grey Suit* and formerly Director of Ting Theatre of Mistakes.

Philip Hughes is a curator, writer and Director of Ruthin Crafts Centre.

Paul Hurley is a Cardiff-based artist working for a PhD in Performance Related Practice at Bristol University. His BECOMING performances have been widely appreciated in the UK and abroad. He is joint instigator, with Sara Rees, of HOTEL ANTELOPE and is working with her on an exhibition shown in summer 2006 in Moscow.

David Lee is a well-known commentator on art and cultural matters and Editor of *The Jackdaw*.

Robert Macdonald was a journalist writing mainly on foreign affairs in New Zealand and Fleet Street. He studied painting at the Royal College of Art, aged 41, and now lives in the Brecon Beacons, exhibits widely and is a vice-chairman of the Welsh Group.

Paul O'Reilly is a freelance curator who was formerly Director of Limerick City Gallery of Art. His text is a paraphrasing of an essay 'Notes and Comments Concerning the Work of Richard Powell', published in *Quarry* (Howard Gardens Gallery, 2000).

Prof Michael Pearson is Professor of Performance Studies in the University of Wales Aberystwyth and has created performances with Pearson/Brookes, including a number of collaborations with Paul Jeff.

Dr Anne Price-Owen is Senior Lecturer in the Faculty of Art & Design at the Swansea Institute, Director of the David Jones Society and Editor of its *Journal*. She has written extensively on the relationship between text and image.

Sara Rees is a Cardiff-based artist and writer. Shown widely in Wales and abroad, she collaborated with Paul Hurley on the HOTEL ANTELOPE project.

Dr Heike Roms is Lecturer in Performance Studies at the University of Wales Aberystwyth and has published widely on contemporary performance practice, in particular on work originating from Wales. She is involved in several artist-run projects and networks in Wales.

Anthony Shapland is an artist, curator and writer. With artist Chris Brown he co-directs the g39 artspace in Cardiff.

Rogelio Vallejo has recently been awarded a Fellowship of the British Higher Education Academy. He is Senior Tutor in the School of Modern Languages at Bristol University, where he directs its unique prize-winning Language Through Theatre course.

Dr Peter Wakelin is an historian and Secretary of the Royal Commission on the Ancient and Historical Monuments of Wales. He writes regularly on art for *Planet*, *The Guardian* and *Art Review*. His 2005 book *John Gibbs and Art Appreciation in Wales* was published to coincide with an exhibition at the National Museum and Gallery, Cardiff.

Index

Aberystwyth Arts Centre 8, 45, 46, 53, 93, 115,
Adam, Barbara 17
Adams, Jonathan 45
Aeppli, Simon 66
Ahtila, Adi Eija-Liisa 68
Arnatt, Keith 5, 15
Artes Mundi 8, 12, 44, 45, 47, 48, 70, 92
Arte Povera 33
Artists' Project 45, 47,
Ashley, Gwenllian 69

Babot, Phil 5, 16, 28, 55, 66
Bahktin, Mikhail 109
Bailey, Peter 56, 75
Baker, Bay 103, 114
Bala, Iwan 5, 8, 9, 11, 40, 53, 55, 60, 68, 88, 109, 114
Barlow, Martin 69, 85, 114
Barn 50
Barrault, Michel 22
Barreto, Emilio 11
Beauchamp, Paul 5, 17
Beckett, Samuel 22
Beuys, Joseph 44, 63, 77
Big Pit 95
Bird, Jon 34, 114
Blake, Peter 56
Blake, William 32
Blast Theory 96
Bonnell, Sian 93
Bower, Ric 59
Bowery, Leigh 32
Brecon Museum 45
Breton, André 32
Brett, Guy 19, 114
Briers, David 35, 115
Briggs, Louisa 52
Briggs, Pat 5, 18
Brith Gof 61
Brown, Chris 9, 26
Butetown History 43
Butler, Susan 5, 19

Caddick, Stefhan 5, 20
Caerdroia Project 43
Cardiff Centre for Visual Art 46
Carver, Julia 52
Castells, Manuel 95, 97
Castle, Bodelwyddan 59
CBAT 12, 47, 67, 70, 115
Centre en Art Actuel 66
Chamberlain, Brenda 53
Chappel, Dick 60
Chapter 55, 61, 69, 89, 93, 96, 97, 103, 115
Charity, Ruth 55
Chtcheglov, Ivan 20
Clarkson, Jonathan 17, 115
Clay, Rawley 67
Coed Hills Rural Artspace 26, 29, 43, 67, 68
Cohen, Bernard 57
Cooper, Victoria Jane 30
Coppock, Christopher 10, 15, 115
Cousin, Michael 5, 21, 65, 76
Cox, Richard 45, 55, 99, 115
Cribb, Laurence 57
Cumming, Donigan 89, 93
Curtis, Penelope 84, 115
Curtis, Tony 55, 57, 115
Cushway, David 65
Cynon Valley 45
Cywaith Cymru 12, 43, 47, 55, 68, 69, 75, 97, 111, 114

Dalí, Salvador 33
Dalton, Gordon 65, 112
Dargan, Sam 60
Davies, Carole-Ann 115
Davies, Geraint Talfan 48
Davies, Grace 75
Davies, Ivor 53, 60, 63
Davies, Jenni Spencer 68
Davies, John 93
Davies, Paul 63
Davies, Tim 9, 43, 48, 65, 96, 97
Demarco, Ricky 11

Dent, Eve 5, 22, 65
Donovan, James 60
Dowling, Sara 101
Dubuffet, Jean 33
Duchamp 31

Edinburgh Festival 11
Eisteddfod 46, 47, 54, 63, 69, 75
Emin, Tracy 44
Emmanuel, Paul 47, 72-74
Emmett, Rowland 35
Evans, Cerith Wyn 48, 65, 69, 108
Evans, John Paul 5, 31

Fairclough, Oliver 55, 115
Fantin-Latour, Henri 52
Farquharson, Alex 64
Fenoulhet, Simon 55, 68
Ffotogallery 45, 47, 54, 75, 89, 93, 114, 115
Fielding, Kim 9, 61
56 Group 30
Finnemore, Peter 4, 68, 69, 88, 89, 109, 115
Firth, Hannah 69, 96
Flemming, Patricia 108
Ford, Laura 5, 32, 48, 68, 69, 106, 109, 110
Francis, Lisa 48
Frayling, Christopher 11, 62
Freer, Steve 58, 115, 116
Fung, Andy 96

G.R.O.U.P 68
g39 26, 29, 45, 65, 66, 76, 116
Gablik, Suzi 50
Galeri 45, 50
Garner, David 43, 49, 60
Genovese, Francesca 100, 115
Gentileschi, Artemisa 54
Giardelli, Arthur 5, 33
Gilbert & George 108
Gill, Eric 57
Gillett, Sara 74, 115

Glynn Vivian Art Gallery 9, 55, 59, 60, 61, 62, 68, 70, 73, 93
Goldsworthy, Andy 33
Golwg 49
Good Cop Bad Cop 61
Gower, Jon 10
Granjon, Paul 5, 34, 66, 68, 69, 95, 110, 111
Gräser, Christian 24
Grennan & Sperando 96
Griffiths, Owen 76, 77
Guthrie, Karen 96

Haines, Bruce 104, 115
Hamilton, Jen 96
Harlech Biennale 29, 45
Hartley, Jennifer 11
Hastie, David 9
Hawgood, Dominic 59
Hawksley, Rozanne 5, 36
Hazell, Andy 5, 35
Herbert, Meriel 65
Hicks-Jenkins, Clive 5, 38
Higlett, Richard 5, 37, 60, 65
Hilary-Jones, Sarah 67
Holland, Harry 5, 81
Hood, Harvey 45
Hotel Antelope 26, 27, 30, 116
House, Gordon 56
Howell, Anthony 31, 115
Hughes, Bethan 69
Hughes, Philip 36, 116
Hurley, Paul 5, 26, 82, 105, 115, 116
Hurn, David 43
Huws, Bethan 48, 108
Huws, Meirion Macintyre 88

Imperial War Museum 36
Ingham, Karen 93
Isaac, Bert 5, 83

Jackaman, Sandra 55
James, Harry 69
James, Shani Rhys 46, 48, 53, 60, 74
Jeff, Paul 101, 116
Jerwood Prize 53
Jones, Angharad Pierce 65
Jones, Catrin 47

Jones, David 52, 57, 115
Jones, Donna 76
Jones, Geoffrey 58
Jones, Helen Ann 5, 85
Jones, Jonah 57
Jones, Mary Lloyd 55, 69
Jones, Yvonne 5, 86

Kahlo, Frida 54
Karam, Nadim 68
Kellner, Thomas 93
Kinsey, Christine 5, 52, 53, 87
Kounellis, Jannis 63
Krikorian, Tamara 75
Kuspit, Donald 44, 50

Lacey, Bruce 35
Ladd, Eddie 43, 55, 66, 111
Lawrence, Philippa 70, 71
Lee, David 81, 116
Lewis, Elfyn 5, 75, 88
Lewis, Thomas 60
Lloyd-Morgan, Ceridwen 52, 53
Luxemburg, Rut Blees 89, 93

MacDonald, Nicolas 75
Macdonald, Robert 38, 55, 116
MacKinnon, Karen 69, 109
Maggs, Richard 72
Marcus, Cathi 76
Margam Park 9
Marshall, Justin 96, 97
McNorton, John 66
Merz, Mario 63
Messerschmidt, F.X. 31
Mission Gallery 18, 36, 76, 77
Molloy, Daniel 60
Mondrian, Piet 33
Moore, Sally 5, 75, 98
Morgan, Richard Huw 60, 61
Morisot, Berthe 52
Morley, David 94, 97
Morris, Cedric 33
Morris, Lynda 55
Murphy, Richard 45
Murray, Michael 30

Nash, David 33, 48, 60

Nash, Will 60
National Assembly 8, 12, 48, 49, 50, 114
National Botanic Garden 71
National Centre for Photography 9
National Museum of Wales 9, 19, 48, 50, 52, 58, 59, 61, 66, 67, 70, 75, 76, 115, 116
National Waterfront Museum 45
New Welsh Review 50
Nixon, Michael 69, 108

Ointment 24, 26, 29, 30
O'Reilly, Paul 116
Organ, Mike 5, 99
Oriel Canfas 62
Oriel Davies 8, 45, 59, 66, 93
Oriel Mostyn 8, 45, 54, 58, 59, 60, 70, 93, 114, 115
Oriel Plas Glyn y Weddw 45
Oriel Q 45
Oriel Ynys Môn 54
Osmond, Osi Rhys 49, 50, 52, 53

Pacheco, Ana Maria 32
Page, Richard 5, 74, 90, 100
Paul Hamlyn Award 104
Paul+a 5, 93, 101
Pearson, Michael 116
Piercy, Jill 52
Planet 50, 116
Pokorny, Marek 65
Pollock, Jackson 33
Pope, Nina 96
Pope, Simon 69, 96, 108
Posey, Emma 96, 97
Powell, Richard 5, 47, 89, 102, 116
Prendergast, Peter 54, 115
Price, Derrick 5, 8, 9, 52, 53, 90, 114
Price-Owen, Anne 18, 52, 55, 87, 116
Pugh, Alun 48

Real Institute/Rêl Institiwt 24, 27, 28, 30
Rees, Marc 43, 111
Rees, Sara 20, 22, 26, 37, 65, 116
Richards, Ceri 7, 53, 60, 83
Richter, Gerhard 31

Riverside Art Centre 45
Robbins, Kevin 94
Rock, Neal 65
Roger, Graeme 27
Roms, Heike 16, 63, 66, 116
Ropek, Eve 53
Rozelaar, Zoe 76
Ruthin Craft Centre 45, 58

Sao Paulo Biennale 47
Savage, Debbie 5, 24, 45, 106, 114
Savage, Jennie 5, 44, 47, 60, 66, 67, 103
Scanner 97
Schleiker, Andrea 64
Sear, Helen 93
Seawright, Paul 69, 89, 93, 108
Second Wednesday 28
Shade, Ruth 50
Shapland, Anthony 9, 21, 55, 65, 116
Soliz, Cecile Johnson 4, 5, 84, 115
South Wales Echo 9
Southern, Jen 97
St. David's Hall, Cardiff 75
Stallabrass, Julian 97
Stitt, André 43, 47, 55, 66, 69, 111
Stokes, Matt 60

tactileBOSCH 30, 45, 61
Taliesin 50
Taylor, John Russell 54
Teran, Michelle 96
Thomas, Ceri 53, 55, 76
Thomas, Dylan 57
Thomas, Ed 42, 50
Tomos, Sian 75
Tooby, Michael 38
Touchstone 50
Trace 17, 26, 30, 66, 72, 103

Umbrella Arts 26, 30

Vallejo, Rogelio 54, 68, 82, 86, 116
Venice Biennale 2, 5, 6, 7, 8, 12, 44, 45, 49, 55, 68, 69, 92, 104, 107, 108, 111, 112, 114, 115
Vettriano, Jack 44

Wakelin, Peter 32, 33, 53, 54, 55, 83, 116
Wales Arts International 7, 12, 45, 47, 114
Wales Millennium Centre 45, 50, 60, 68
Webster, Catrin 45
The Welsh Group 30, 45, 116
Western Mail 10, 48
Whitehead, Simon 24, 26, 27, 44
Wilkins, William 45
Williams, Bedwyr 5, 42, 45, 60, 65, 68, 69, 89, 93, 104, 111, 112
Williams, Emrys 60, 61
Williams, Jeni 55
Williams, Karla 5, 105
Williams, Lois 60
Williams, Sue 48, 53, 70
Wolfe, Tom 10
Wood, Craig 65

Y Lle Celf 47
Y Tabernacl (MOMA) 45, 83

Zobole, Ernest 53, 55, 60, 76

Gwyn, Llangennech Park 1970 | Sunrise over Llanelli from Furnace | Politic

Prisoners | Bethan in a Ball Pit | Cockle Pickers – Burry Estuary | Ferrysi

Signal Box | Abstract with Fish | Two Farmers Talking | Brazilian Woman

Mum and Dad Before | Mwmbwls | Greenfield Chapel, Sunday Best | Bor

Banker's Wife | The Fish | Model Reclining | Candelabra on a Welsh Dress

| Evening Feed | But I can't See Anything | St Govans Chapel | Bluebells

Cwta Wood, Furnace Pond | Baglan Nightscape | Market Gossip, Carmarthen

Abstract | Llanegwad Village | Nuthatch on a Tree | Pink Geranium in a Brou

Pot | Self Portrait | Morning Shift, Six till Two | Brythnod | Atmospheric

Jelly, Sponge and Teisen Lap | Love the Words | Blue Tit | Afon Morlais at

Eglws Farm, Llangennech | Cloth Cap Image | Flora Fantasy | Out of the Bl

| Pistyll Rhaeadr | The Tearjerker Early Morning, Talyllyn | Little Venic

Colmar | Still Life (Flemish Style) | Remember Manorbier